Postcard History Series

Around Hazleton

POSTCARD HISTORY SERIES

Around Hazleton

Richard W. Funk

Copyright © 2005 by Richard W. Funk
ISBN 0-7385-3739-X

First published 2005

Published by Arcadia Publishing,
Charleston SC, Chicago IL, Portsmouth NH, San Francisco CA

Printed in Great Britain

Library of Congress Catalog Card Number: 2004117630

For all general information, contact Arcadia Publishing:
Telephone 843-853-2070
Fax 843-853-0044
E-mail sales@arcadiapublishing.com
For customer service and orders:
Toll-free 1-888-313-2665

Visit us on the Internet at www.arcadiapublishing.com

Contents

Acknowledgments		6
Introduction		7
1.	A Bird's-Eye Perspective	9
2.	Street Scenes	19
3.	The Coal Industry	39
4.	Other Businesses and Industry	49
5.	Schools	61
6.	Churches	71
7.	Public and Private Buildings	83
8.	Transportation	95
9.	Parks and Recreation	113

Acknowledgments

Although the images and text of this book were organized and written in the space of three months, learning much of the history contained here was due to years of researching and writing historical articles for two local newspapers. Along that road, several people shared their knowledge of the Hazleton area. One of those people was John "Jack" Koehler, Weatherly historian, author, and noted expert on the Lehigh Valley Railroad. Through the years, he has helped me with many newspaper articles. I truly owe you one.

Thanks are extended to Chris Crosley of White Haven, who shared several images included in this book. Chris also shared his wide knowledge of White Haven area history.

A very, very special thank-you goes out to my close friend, Phil Kaufman of West Hazleton, who supplied me with an office that provided the peace and quiet needed to complete this work.

I must also extend thanks to my children and to my partner, Linda. During the times when working at home, my son Bob and daughter Susan did their best to give me space to write. On the times when I would slack off, Linda would nudge me along. Thanks go out to my oldest daughter, Janine, who was expecting me to visit her home in Brooklyn, New York, but understood that it had to be postponed until this was completed.

Introduction

There is a good chance that had it not been for the rich deposits of anthracite coal that were discovered, the land now occupied by the city of Hazleton would probably be little more than a swamp on top of a mountain today. But, when coal was found there in 1826, a chain of events began that altered the region significantly, and the Hazleton Coal Company was established 10 years later.

Unlike many other cities, Hazleton was never truly planned, and its growth came when small patch towns were absorbed into its borders, thus creating a city from small clusters of homes built by mining companies. But while coal mining was increasing, growth was not immediate, and those living in early Hazleton often had to travel east to Beaver Meadows to shop for needed items.

Although it has a rich history, Hazleton apparently did not look to the past to create a future, and during times of urban renewal, many historic buildings, such as the Lehigh Valley Railroad station, fell to the wrecking ball. The area's industrial heritage did not fare better, and of the many coal breakers that once rose above the stripped landscape, not a single example remains standing in the area today.

While King Coal was responsible for fueling the industrial revolution, his reign was not destined to last forever, and after World War II he was dethroned by fuel oil and natural gas. And while coal mining was not the only industry in the region, its demise dealt the area a significant economic blow from which it took years to recover.

Coal was the common denominator that linked towns in the Hazleton area, although not all produced the shiny, black mineral. For example, anthracite was never mined in Weatherly, but the town was an important early railroad center that served the coal industry. Lumber milled at White Haven was used by mining companies to build many of the area's first patch towns. Along with producing lumber, Rockport was an important place on the Lehigh Canal, and cars of coal transported on the primitive but functional Buck Mountain Railroad were unloaded into canal boats waiting there.

The entire Hazleton area has a rich and varied history, but because postcard views of some towns are not known to exist, it was impossible to include them here.

I have attempted to keep this work as accurate as possible, but sometimes history can be subjective, and what is fact to one person is not the same to another.

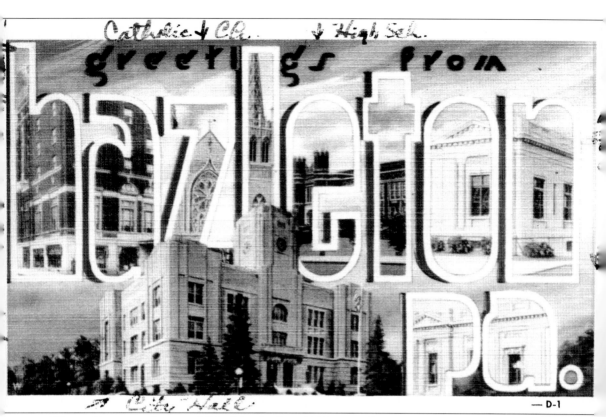

When this postcard was published in the late 1930s or early 1940s, Hazleton was east-central Pennsylvania's capital of anthracite production. Atop a mountain, Hazleton has the distinction of being the highest city in the state. Nearby Freeland is the highest borough in the state.

One
A Bird's-Eye Perspective

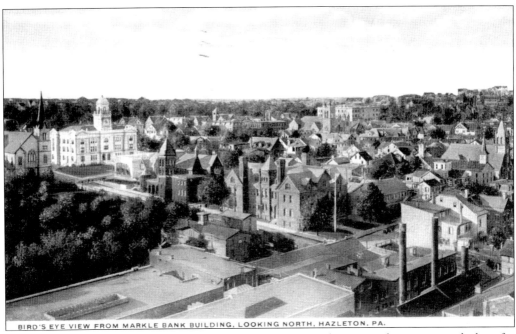

Hazleton's Markle Bank Building is the tallest structure in the city and was a natural place for photographers to make bird's-eye view images. Looking northwest, this view shows the Green Street School in the foreground, and city hall is the tall white building to the left. The wooded area in the left foreground was Pardee Square.

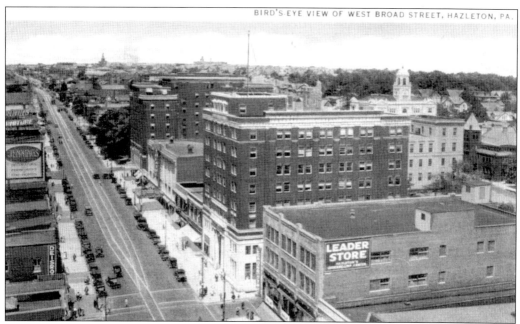

Probably photographed from atop the Markle Bank Building, this view looking northwest shows the heart of Hazleton's downtown shopping district. The block of buildings in the foreground, bounded by Broad, Church, Laurel, and Green Streets, was constructed in the 1920s at the site of Pardee Square, which contained the sprawling Pardee Mansion.

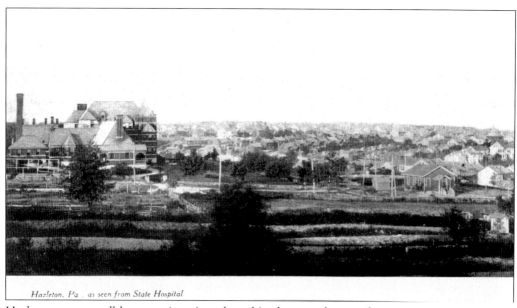

Hazleton was a small but growing city when this photograph was taken c. 1905. Looking west, this image was captured from a rise east of what was then the state hospital. Many of the houses to the extreme right are gone, as is what appears to be a one-room school, one of more than 30 schools that operated in the city at one time.

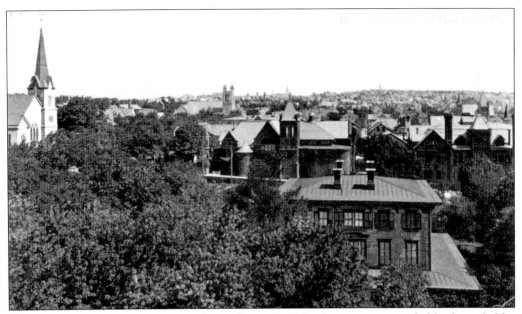

Virtually secluded in center city Hazleton, the Pardee Mansion sat on a wooded lot bounded by Laurel, Broad, Church, and Green Streets. The mansion, built in 1859 by coal mine operator Ario Pardee, the building contained 30 rooms. During the 1920s, the landmark was removed, and today the block is made up of commercial buildings.

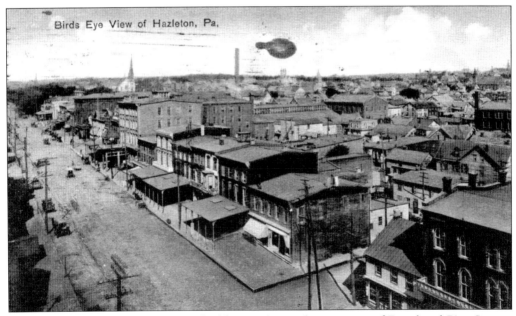

Probably photographed from atop a building at the southeast corner of Broad and Pine Streets, the block between Pine and Wyoming Streets, bounded on the south by Broad Street and on the north by Green Street, is in the foreground. Building density in the city's downtown may have been at an all-time high when this image was made in the early 1900s.

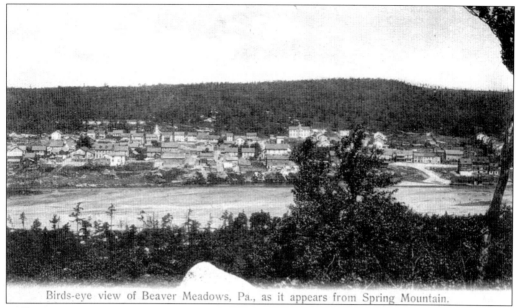
Birds-eye view of Beaver Meadows, Pa., as it appears from Spring Mountain.

Before Hazleton grew to become Lower Luzerne County's shopping and business center, many early residents traveled several miles east to Beaver Meadows to make purchases in stores found there. The first settlers of Beaver Meadows, a very remote area, frequently saw Native Americans traveling down the mountain and into town on Warrior's Path. Later, the Lehigh and Susquehanna Turnpike passed through town, and a turnpike toll gate was established at the base of the Spring Mountain, east of town. This view, looking north from the Spring Mountain, shows the small Carbon County borough as it appeared in the early 1900s.

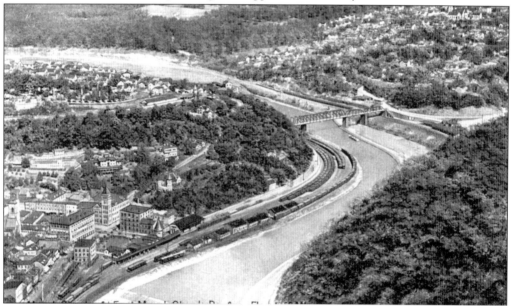

Mauch Chunk, today known as Jim Thorpe, was a short trip and popular destination for Hazleton area residents who wanted to spend a day out of the city. Known as the "Switzerland of America," the town was served by both the Lehigh Valley Railroad and Central Railroad of New Jersey. It was also home to the famous switchback railroad.

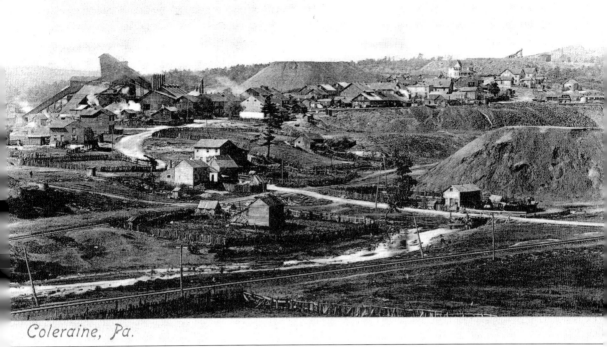

Coleraine, Pa.

If ever an image defined a patch town, this is it. Midway between Beaver Meadows and Tresckow, and today known as Junedale, Coleraine was a typical company town, built to house those who worked in the coal industry. The towering coal breaker and its associated powerhouse can be seen to the left. Many of the houses shown in this 1906 view are still standing, but today the village of Banks Township is home to fewer than 100 people. Patch towns were generally built near the local colliery and offered virtually everything needed by the residents. All had company stores, a school, barrooms, and churches. At its height, Coleraine boasted two houses of worship, a large school, and a train station served by the Lehigh Valley Railroad. Today, there is no trace of the railroad tracks shown at the bottom of this view, and the breaker has been gone for many years.

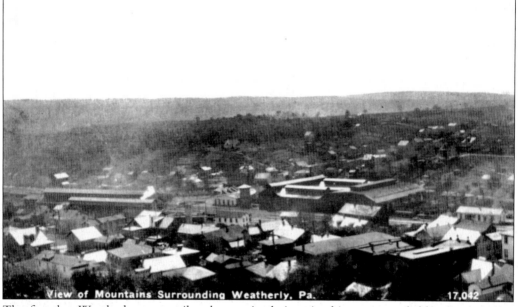

The fact that Weatherly was a railroad town is obvious in this scene, probably photographed from the Mrs. C. M. Schwab School. In the foreground is the former Lehigh Valley Railroad shop complex, and the long buildings to the left were the car shops on what is now the site of a shopping center.

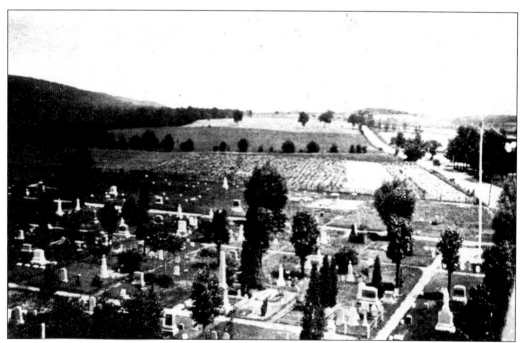

Being one of the highest points in Weatherly, the Mrs. C. M. Schwab School was often used by early photographers to make bird's-eye views. This scene, looking east, shows Union Cemetery and East Main Street. The same view today shows the street lined with homes and a new street to the left, which leads into a section of town developed in the late 1960s.

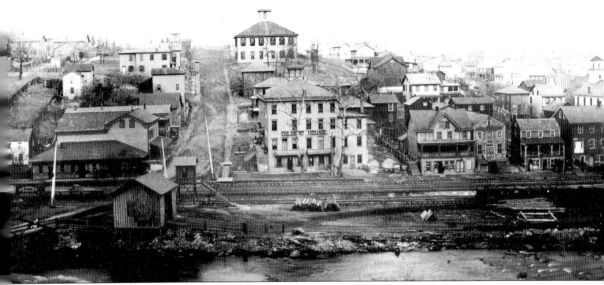

One of the earliest views of Weatherly known to exist, this scene of the borough's downtown section was probably photographed from the Rocks in the town's west side. The view predates 1888, as the old Lehigh Valley Railroad station, shown in the lower left, was still in operation, and the site of the new station, completed in 1889, contains railroad tracks, loaded coal card, and lumber. Also shown are the Gilbert House, in the foreground, and the Oak Grove Seminary School, at the top. The original railroad station, Gilbert House, and school are no longer standing, and through the years, several other buildings shown here have also been razed. It is interesting to note that Black Creek was much wider at this time, which led to Weatherly's many problems with flooding in its early years.

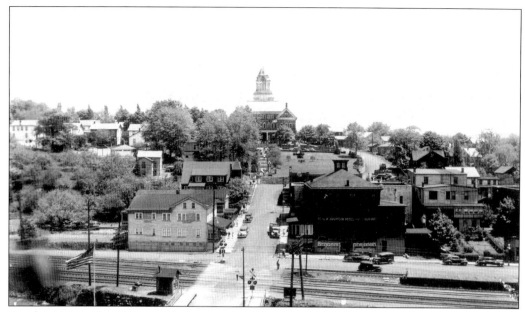

By the 1940s, the Gilbert House was the New American Hotel and Restaurant, and the American Store occupied the building's ground floor. Probably photographed in early fall or late spring, the steps leading to the Mrs. C. M. Schwab School are crowded with students returning to classes. Traditionally, many students walked home or went downtown for lunch.

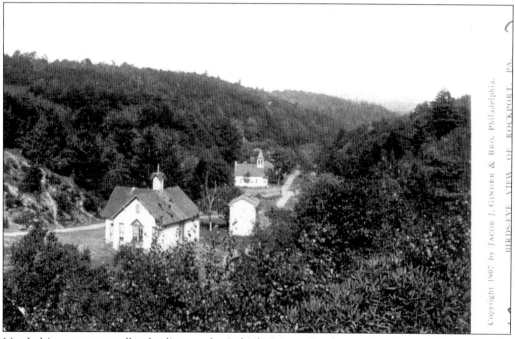

Nestled in a narrow valley leading to the Lehigh River, Rockport dates from 1824, when the Lehigh Coal and Navigation Company purchased lumbering rights to the area. Although it never boasted a large population, the village was home to four sawmills, a post office, school, and possibly two hotels. The Buck Mountain Railroad terminated at the river's edge, where coal was loaded into barges of the Lehigh Canal.

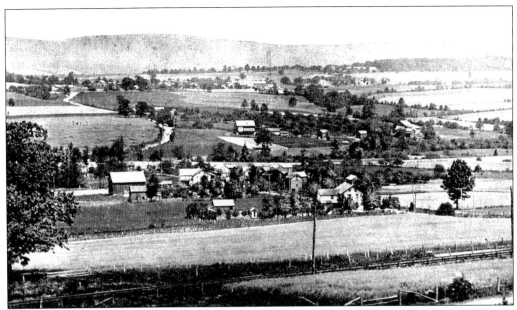

North of Hazleton and Freeland, the fertile Butler Valley was rural farm country that helped supply the Hazleton area with fresh produce, fruit, and some livestock. Although still farmed to some degree, the valley has become popular with developers, and today many new homes dot the landscape that was once mostly open space.

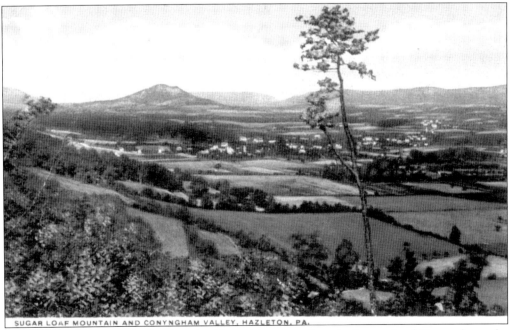

Including parts of Sugarloaf and Butler Townships, as well as the borough of Conyngham, the Conyngham Valley experienced a population explosion in recent years when many housing developments were built there. In the left foreground is Sugarloaf Mountain, which rises from the valley floor and is a local landmark. In the background is the Nescopeck Mountain.

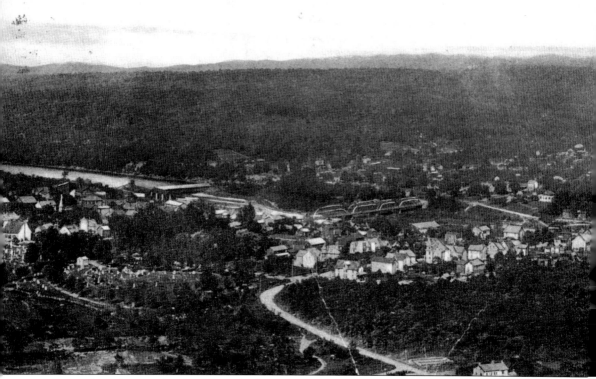

Bird's Eye View of White Haven, Pa.

Located on the west bank of the Lehigh River, White Haven was once known as Linesville and was the northernmost stop on the Lehigh Canal. Having a rich supply of forests available nearby, White Haven grew to become a lumbering center with at least 1,000 workers employed in the local timber and milling trade. By 1860, almost two-thirds of Pennsylvania's milled lumber was shipped from this Luzerne County community. The town was also served by both the Lehigh Valley Railroad and New Jersey Central. This view, looking northeast, also shows the Carbon County borough of East Side across the bridge and river in the foreground.

Two
STREET SCENES

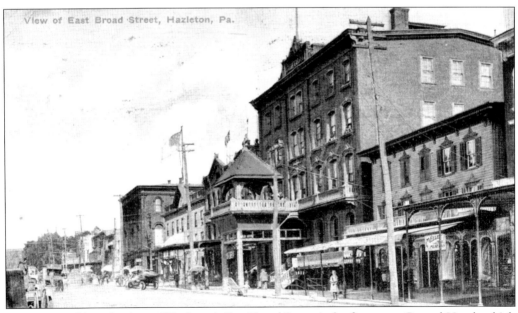

Dominating this early view of Hazleton's East Broad Street is the five-story Central Hotel, which was built in 1880. It later became known as the Hotel Loughran and later still the Hotel Gary. Hailed as being fireproof, the building was gutted by flames on the cold and windy night of March 5, 1959. The blaze was the city's deadliest fire.

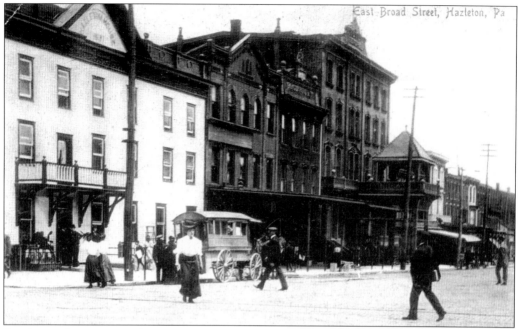

On the northeast corner of Broad and Wyoming Streets, the Hazleton House, to the left, was built in 1837 and was the city's oldest building until it was razed in 2003. Parked in front of the hotel is what appears to be a horse-drawn lunch wagon. The tall building to the left is the Central Hotel.

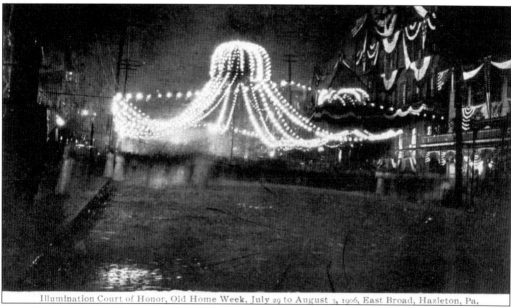

Several ghostly apparitions can be seen around the court of honor during Hazleton's 1906 Old Home Week celebration. The images were actually created by people walking through the camera's field of view while the shutter was left open to create the night shot. The photograph was taken looking west on East Broad Street with the Central Hotel directly to the right of the illuminated court.

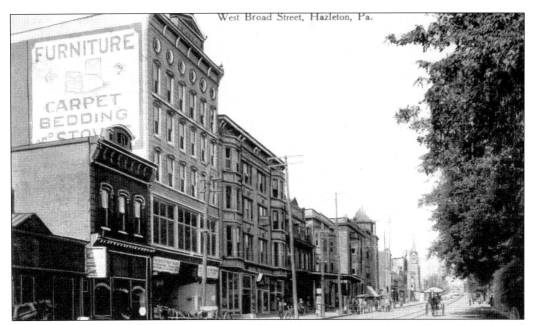

This 1905 view was taken looking west on Broad Street toward Church Street from Laurel Street. The downtown area was the region's center of commerce, and many important buildings were located there. Horse-drawn carriages were the common form of transportation, and trolleys made frequent trips up and down the wide street.

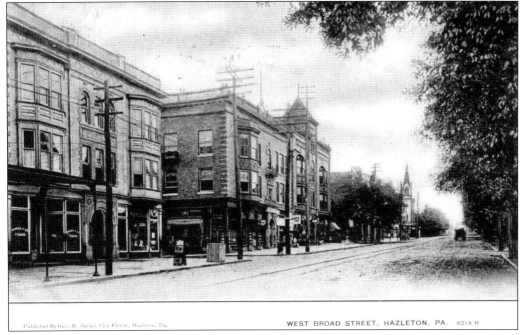

The area's two main highways, Routes 93 and 309, meet here at the intersection of Broad and Church Streets, which is a busy place today. Of the buildings shown in the foreground and left, not one remains standing. The landmark Deisroth Building, to the left of the intersection, has been replaced by a modern office building.

The Iron Front Building, second from the left, was built in 1875 and originally housed the Pardee, Markle, and Grier Bank. By 1910, the 12-story Markle Bank Building had been completed, and 13 years later the company store, to the right, had been razed and an addition built on the bank.

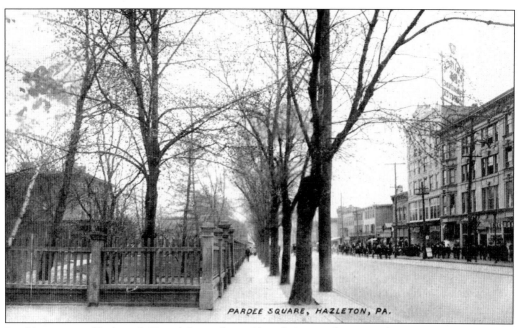

Looking east on Hazleton's Broad Street from Church Street, this view shows Pardee Square and the Pardee Mansion on the left. The Altamont Hotel now occupies this corner, and other commercial buildings were constructed east to Laurel Street. The Pardee Mansion contained a fireplace in each room and four central chimneys.

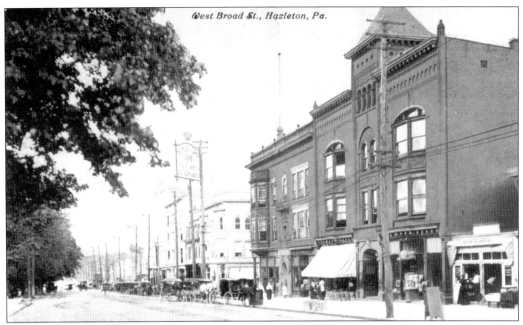

Hazleton's West Broad Street is shown looking east toward Church Street. The tall brick building to the right was the YMCA, while the structure to the left was called the Seager Building. All buildings shown to the right were razed years ago, and today the block is dominated by the Hazleton Philharmonic building, a bank, and several other businesses.

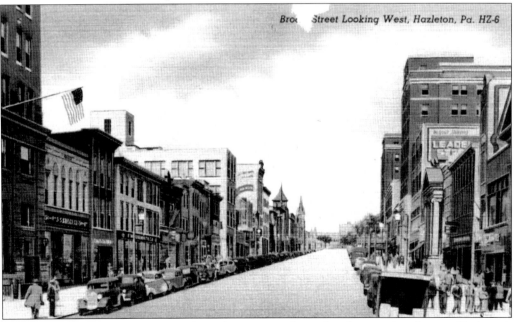

Seen in a view looking southwest from the corner of Broad and Wyoming Streets, Hazleton's downtown business district featured large chains such as Woolworth's and S. S. Kresge, both commonly called five-and-dime stores. It also contained many locally owned stores and shops. Unusual for many cities, Hazleton's Broad Street attributes its four-lane width to once having been the route of the Lehigh and Susquehanna Turnpike.

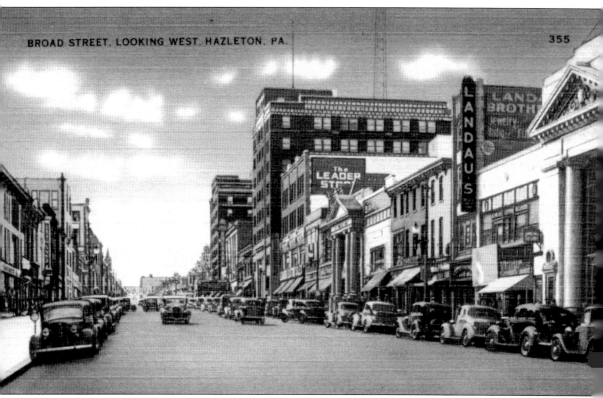

The north side of West Broad Street, between Wyoming and Laurel Streets, was home to many businesses, including what was once the popular Leader Store and Landau Brothers. The tall, brick office building in the foreground was the Hazleton National Bank Building, and on the same side of the street farther west is the Altamont Hotel. When the first white travelers came to the Hazleton area, they found a great swamp in this area of the city. The area was then called Hazle Swamp. Later, the Lehigh and Susquehanna Turnpike was constructed over Warrior's Path.

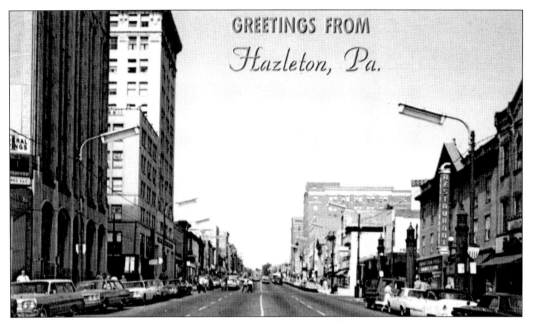

In the 1960s, Hazleton's downtown shopping district was still bustling with activity. Lined with stores of all descriptions, banks, and restaurants, this was the place to go for shopping. When shopping centers and a mall were built outside the city, many businesses here closed and remained vacant until the city's downtown began to make a comeback in recent years.

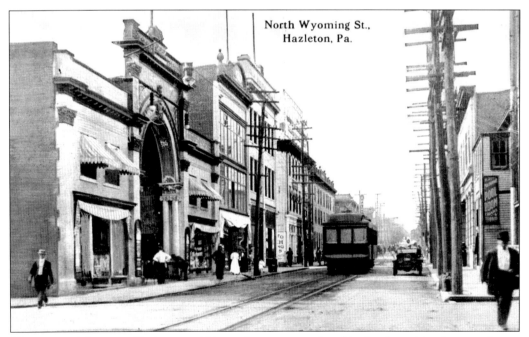

The automobile was still the new kid on the transportation block when this photograph was taken, and most people relied on rails or walking to get from one place to another. At the southeast corner of Wyoming and Green Streets, the building with the arched entrance (left) was Hazleton's Palace Theater, which was destroyed by fire several years after this image was taken.

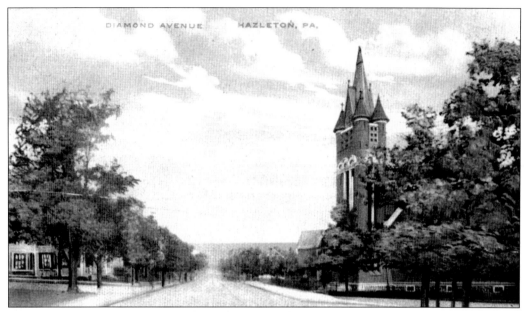

Diamond Avenue was not yet lined with houses and businesses when this image was made in the early 1900s. To the right is a church that was originally known as the English Reformed Church and later Emmanuel Reformed Church. Services are still held in the church (built in 1854), but by a different denomination.

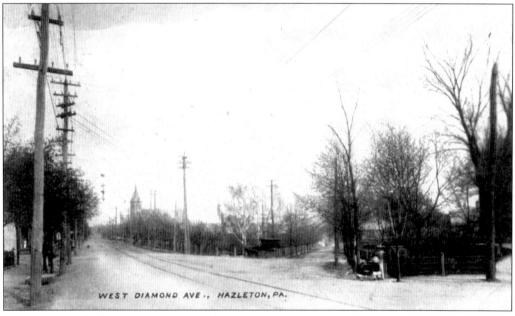

Seen in a view looking east on Diamond Avenue toward Church Street, the wooded area in the foreground is Memorial Park. Land north of Diamond Avenue was annexed in 1885 by what was then the borough of Hazleton, which was incorporated as a third-class city on December 4, 1891. This early view was photographed from a spot just east of Alter Street.

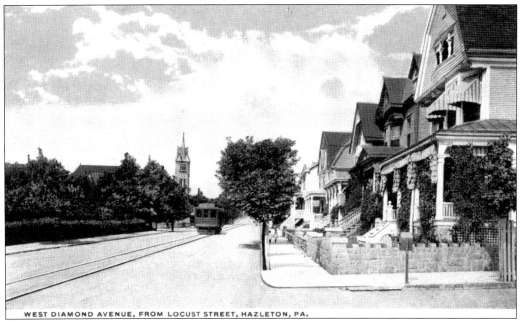

The description printed on this card from the 1920s is not correct and should read, "West Diamond Avenue, from Laurel Street." Locust Street is several blocks from where this photograph was taken. The tall building rising above trees in the left background is Emmanuel Reformed Church, located at Diamond Avenue and Church Street.

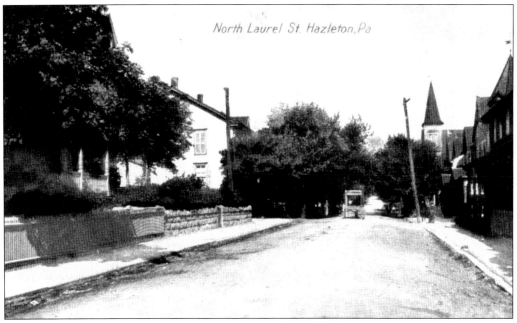

Looking north on North Laurel Street from Hemlock, this view shows the former Grace Reformed Church in the right background. The church, along with four others, closed several years ago. The congregations now make up Faith United Church of Christ, and their house of worship is located in Hazle Township.

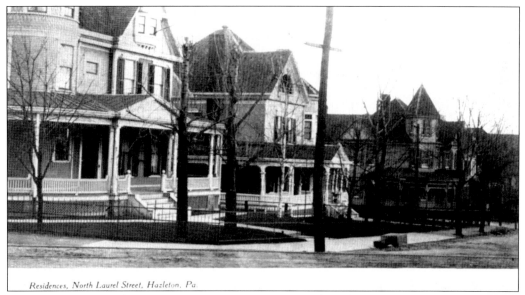

In the Hazleton area, the Pardee name was synonymous with coal mining. To the left is the Israel Platt Pardee Mansion, located at 235 North Laurel Street. Constructed in 1893, the Queen Anne–style building was included on the National Register of Historic Places in 1984. Today, it is used as an apartment house.

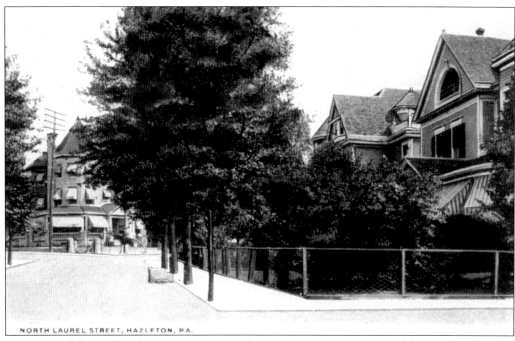

North Laurel Street, looking toward Diamond Avenue, was where some of the city's largest and most expensive homes were built. Some of the city's richest business owners lived in this neighborhood, which today remains residential. Once sprawling homes and mansions for the wealthy, these homes are still standing, but they now contain apartments.

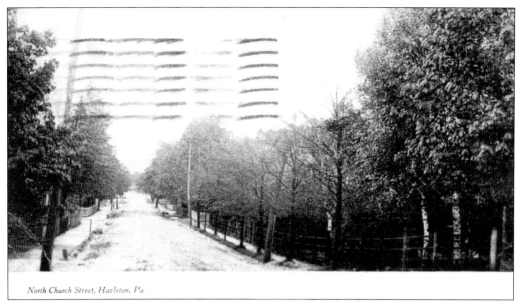

In 1905, this section of Hazleton's North Church Street looked more like a country road than a city street. This view may have been taken looking south from Diamond Avenue. Church Street was, and continues to be, the main north–south route through the city, and today it carries Route 309 through Hazleton.

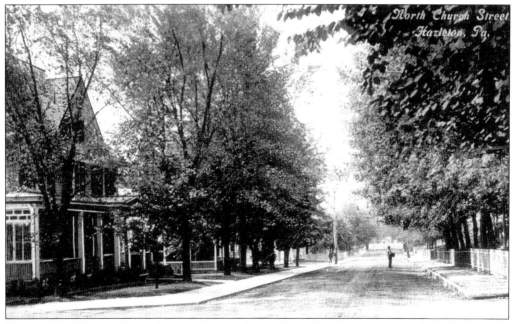

This image of North Church Street was probably made c. 1906 and looks south from Fern Street. Several blocks south of this location is city hall and the Hazleton Public Library, while Diamond Avenue runs east–west just to the north. Because of the lucrative coal industry, many large homes were built in this neighborhood, and many remain standing today.

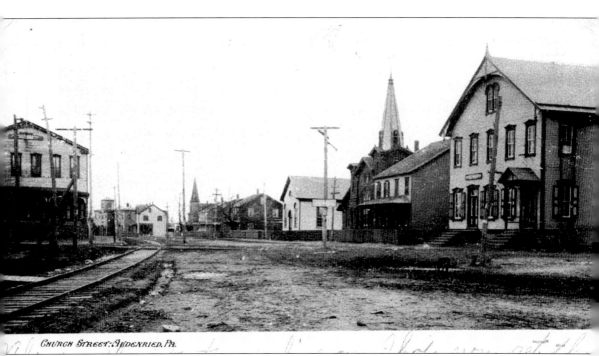

Church Street, Audenried, Pa.

South of Hazleton and north of McAdoo, the Banks Township village of Audenried was a bustling place during the era when coal was king. Along with the mines found there, the village had a large school, stores, hotels, and churches, and it was served by the railroad. Some parts of the village were removed for coal-stripping operations. Population density in the general area must have been quite high, as Audenried was surrounded by other places, such as Beaverbrook, Honeybrook, Yorktown, and the halfway houses between the village and McAdoo. The site where the halfway houses were located was stripped away to remove coal, and not a trace of Honeybrook remains. The village even boasted a silk mill, the M&K Silk Mill, which in 1919 was operated by Theodore Michael and Louis Kreiger and located in Hosack Hall. The firm employed 58 people, but it relocated to Beaver Meadows in 1921. At the village's height, it contained four churches of different denominations.

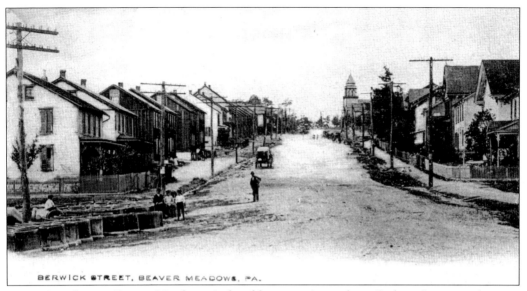

Beaver Meadow, or Beaver Meadows, is the oldest town in northern Carbon County and was an important stop on the Lehigh and Susquehanna Turnpike, which was completed in 1806. Berwick Street follows the old route of the turnpike, and this view looks west, toward Hazleton, approximately three miles from this location.

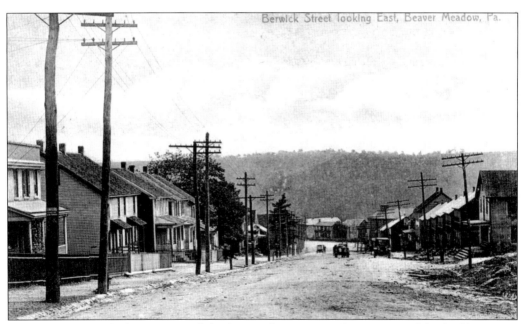

This *c.* 1906 view looks east toward the heart of Beaver Meadows. Most of the buildings seen here are still standing. Berwick Street is today Route 93 and traces its origin to the Lehigh and Susquehanna Turnpike. Spring Mountain is in the background.

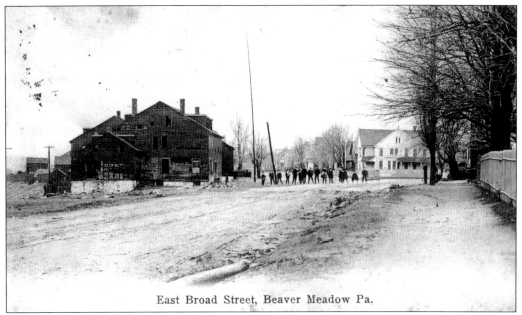

East Broad Street, Beaver Meadow Pa.

Beaver Meadows traces its origin to 1813, when coal was found nearby. Although anthracite was slow to become accepted as fuel, once it was, there was nothing to stop it until fuel oil gained popularity. This view shows East Broad Street and a group of children. The dark buildings to the left are in an obvious state of disrepair.

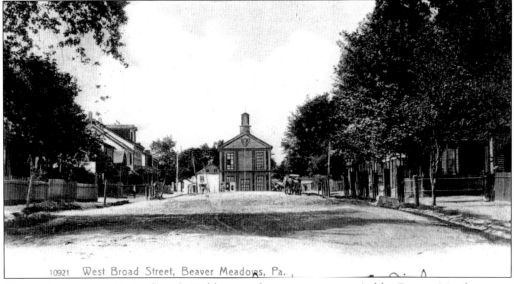

10921 West Broad Street, Beaver Meadows, Pa.

Originally known as St. Anthony's Wilderness, the area now occupied by Beaver Meadows was reportedly so wild that even Jesuit missionaries were afraid to go there. The borough began to grow after coal was found nearby in 1812, and by 1836, the Beaver Meadow Railroad ran from the town to a connection with the Lehigh Canal at Penn Haven.

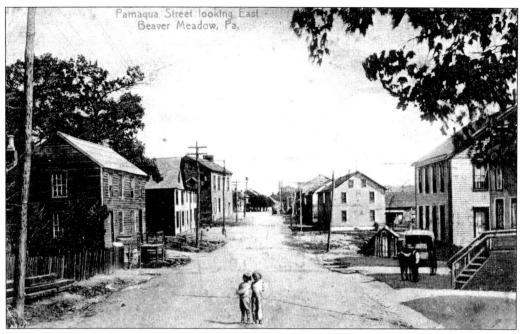

This early view of Beaver Meadows shows Tamaqua Street rather than Pamaqua, as is printed on the card. This was the view that greeted those traveling to town from Coleraine, now Junedale, approximately one mile to the west. Several homes shown here remain standing, but they have been updated.

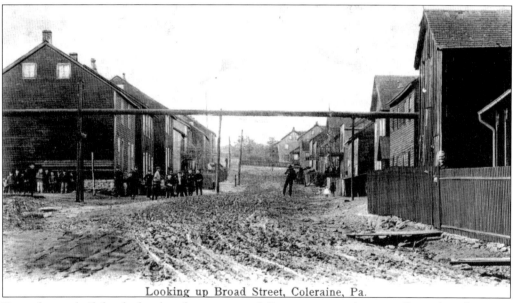

Frame homes built by the local coal company and dirt streets were the norm for coal patch towns. Known today as Main Street in Junedale, this scene typifies the towns miners and their families called home. Many of the houses shown in this c. 1906 view are still standing, but they have since been updated. The overhead pipe probably carried water to the breaker's powerhouse, which is out of view to the left.

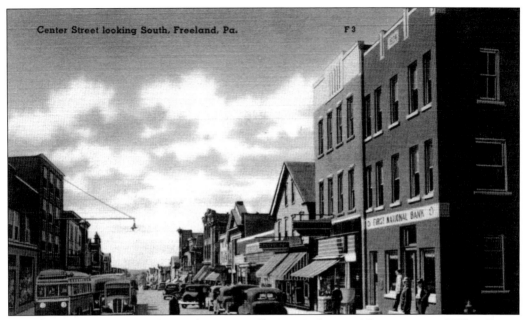

Long before people started traveling to malls in Hazleton, Allentown, or Wilkes-Barre, downtown was the place to go for shopping. Freeland's Centre Street was a bustling place in the 1930s, as is evidenced in this view of the borough's shopping district. Back then, there was no real need to travel outside of town for most needs.

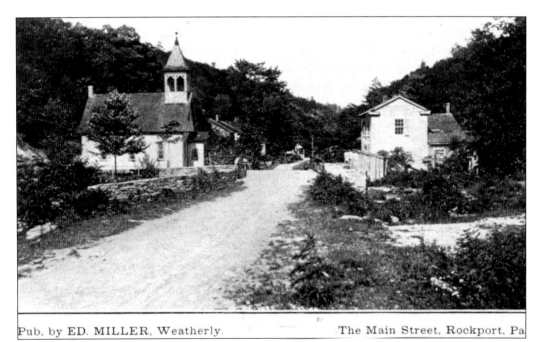

Rockport's Main Street has not changed greatly since this photograph was taken c. 1905. St. John's United Church of Christ, to the left, was dedicated on June 9, 1895, and is still standing, as is the house to the right. Prior to the church being built, the congregation met in the nearby Rockport School. Several of the buildings shown in the background have been razed.

Identified as "Hudsondale Street heading into Weatherly," judging by the mountains, this early scene is more than likely a view of East Main Street, at the Weatherly end of the Weatherly–White Haven Road. Today, the fields on both sides of the road have been replaced with homes.

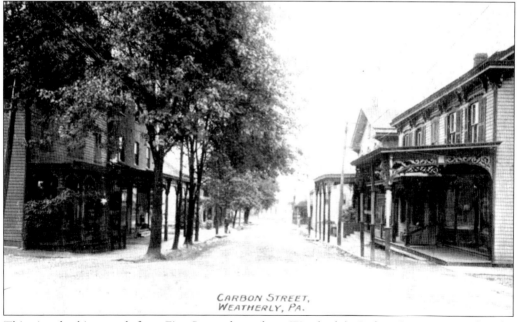

This view looking south from First Street shows how Weatherly's Carbon Street appeared in the early 1900s. In 1888, Carbon Street was the first in the borough to be covered with macadam, from East Main Street to First Street. Continuing south was Railroad Street, which was renamed Carbon Street in 1917.

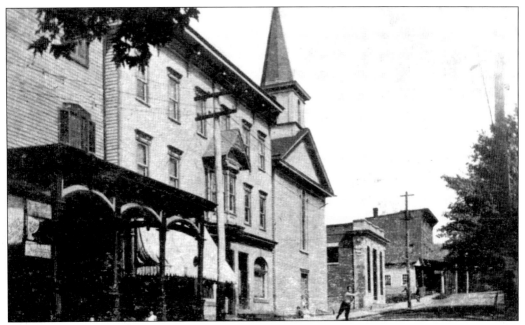

The Methodist church, built in 1866, is in the foreground of this view looking north on Weatherly's Carbon Street. The building was torn down in 1950, and a new church was constructed. The dedication for the new building took place on June 10, 1951. While construction was ongoing, members met in the cafeteria of the Tung-Sol plant. The First National Bank is to the right of the church.

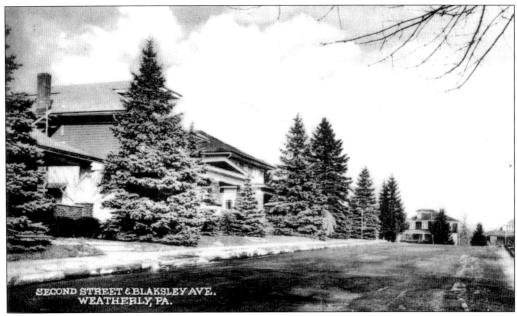

Over the years, housing in the borough of Weatherly grew eastward, and many new homes were built in the area around Second Street and Blakslee Avenue. Weatherly was hit with a housing boom in 1972, when a $2.5 million development was built in the northeast corner of the borough. With this development came two new roads, Norman and Louise Streets.

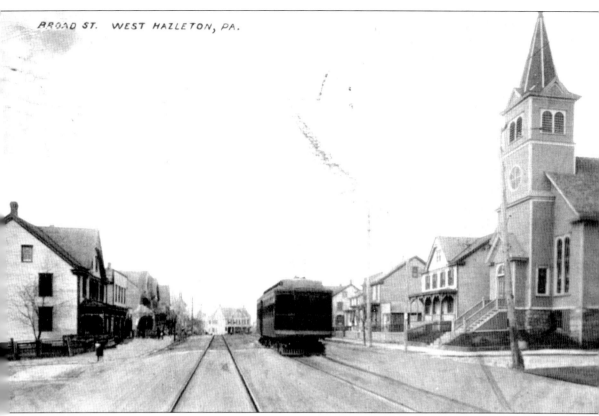

Two sets of trolley tracks are visible in this westward view of West Hazleton's Broad Street. Adjoining the city of Hazleton's west side, West Hazleton was incorporated as a borough in 1889 and is also bordered by Hazle Township. Heavily residential, the borough also had the usual assortment of stores, churches, and hotels.

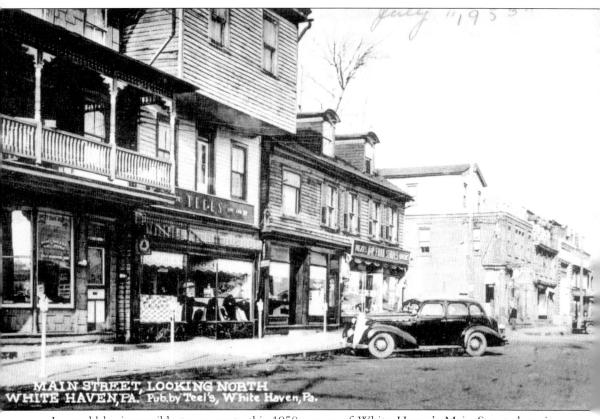

It would be impossible to re-create this 1950s scene of White Haven's Main Street shopping district. All three buildings shown to the left were destroyed in a 1987 fire. They included Teels, a stationery and variety store, and the former A&P (to the right). Most of the buildings to the extreme right remain standing.

Three
THE COAL INDUSTRY

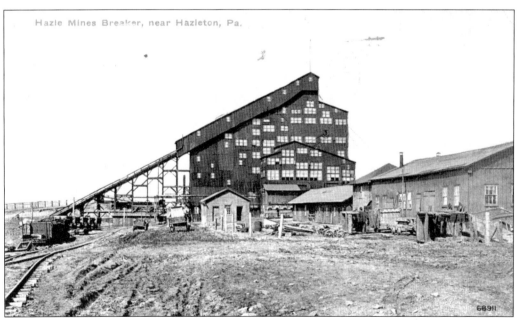

The old Hazle Mines coal breaker was just to the west of the present-day Hazleton Shopping Center on West Broad Street. Coal was responsible for fueling the local economy, and the industry was dominated by families bearing the names Coxe, Pardee, Van Wickle, and Markle. Coal continues to be mined in the Hazleton region, but production is a tiny fraction of what it was in years past.

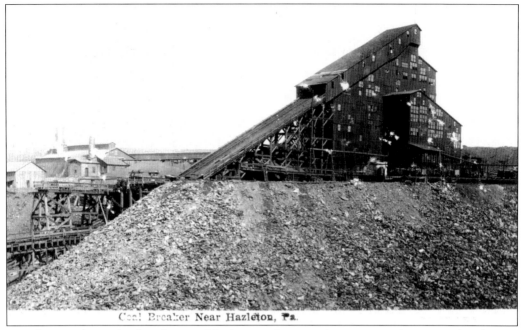

Coal Breaker Near Hazleton, Pa.

In order to reduce mined coal to useable sizes, coal companies constructed towering breakers to crush and sort the coal. The job of picking refuse from the flowing black stream of coal fell to breaker boys, some as young as eight years of age. This is likely the Hazle Mines breaker.

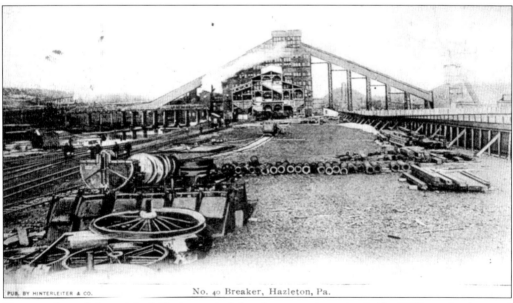

No. 40 Breaker, Hazleton, Pa.

Construction of the original Hazleton shaft breaker started on April 15, 1898, on land east of Cedar Street. The site has a long history of coal processing, and it was advantageously located near the Lehigh Valley Railroad's line coming into and leaving the city. Mines in this area were drained of water by the Jeddo Tunnel.

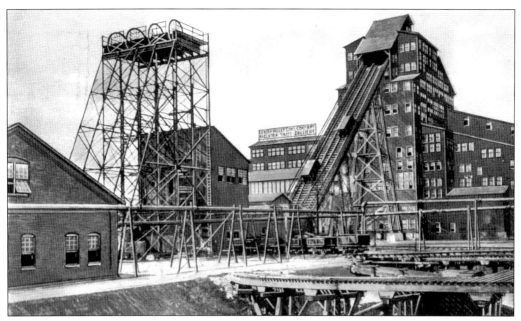

The Lehigh Valley Coal Company's Hazleton shaft colliery was a fixture in the city's east side. After World War II, anthracite coal lost its popularity as a home heating fuel, and most people switched to fuel oil or natural gas. The loss of business left many collieries idle or with greatly reduced production. This breaker was razed in the late 1990s, and a smaller, modern facility was built nearby.

Although underground mining was still being conducted in the region in 1905, some larger coal operators were using the strip-mine technique. During this procedure, it was common to find old tunnels, as shown in this view. Strip mining is still conducted in the region, but on a much smaller scale.

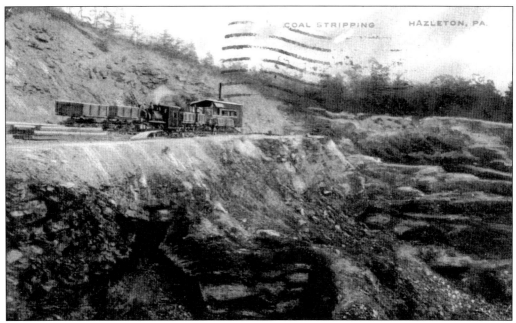

Early strip-mine operations left parts of the Hazleton area scarred. Before huge dump trucks were used to transport coal and overburden, mine operators often laid narrow-gauge rails to the site, and commonly small switching engines were used to move loaded cars from mine to breaker and empty cars from the breaker back to the active mining area.

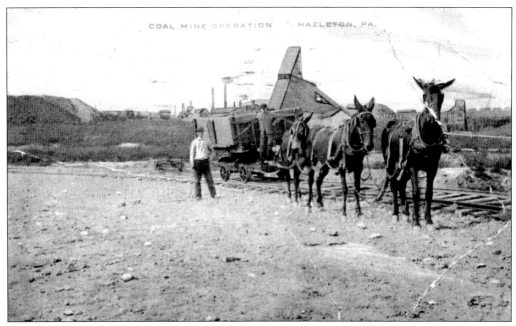

Most collieries relied on mules, often driven by boys, for transportation both below and above the ground. This scene likely shows a car of waste coal, known as culm, being taken to the dump. Through the years, these piles of waste coal grew into the black mountains that still mark the Hazleton area.

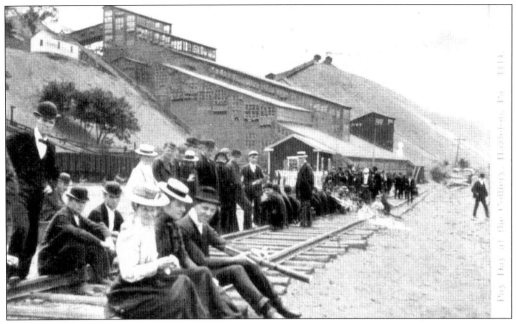

For mine workers, payday usually came once a month and was cause for celebration. However, wages were generally very low, as deductions were made for housing, purchases at the company store, the doctor's monthly fee, and at many collieries, the services of a priest. Other deductions included power for blasting and for tools needed to do the dangerous job of mining coal.

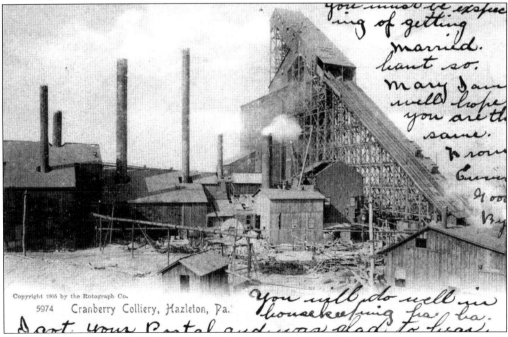

Southwest of Hazleton, the Cranberry breaker was going strong when this image was captured in 1905, and it was known as one of the tallest coal breakers in the region. At one time, the colliery was operated by A. Pardee and Company and later the Lehigh Valley Coal Company. In its heyday, the village of Cranberry had approximately 500 residents.

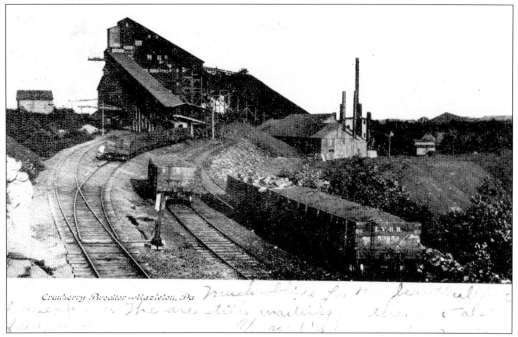

Coal mining and the railroad industry lived a codependent relationship for many years, and most mines were owned or controlled by railroads like the Philadelphia and Reading or the Lehigh Valley. In this view from the early 1900s, coal cars of the Lehigh Valley Railroad wait at the Cranberry colliery for transport to market.

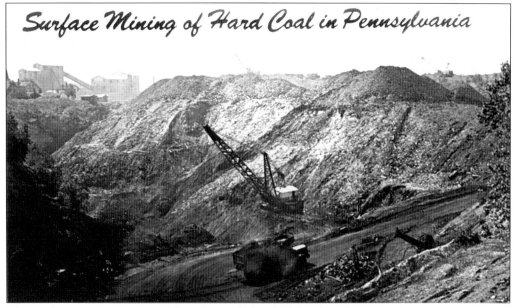

The coal-stripping pits remain, but the steel-sheathed breaker shown in the rear is gone. This photograph was taken near the line dividing Schuylkill and Carbon Counties between McAdoo and Audenried. The breaker was one of the few standing in the region, and out of the many that dotted the Hazleton area landscape, not one has been preserved.

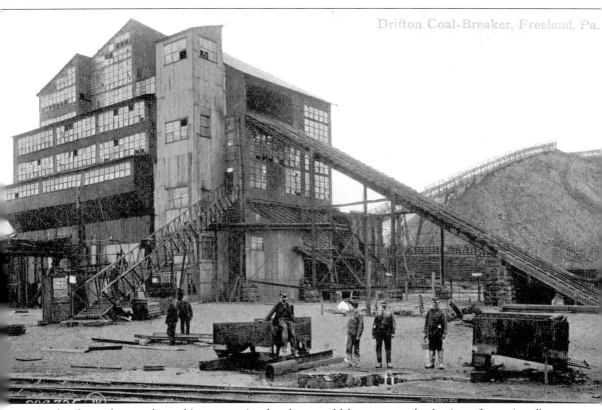

In the days when coal was king, towering breakers could be seen on the horizon from virtually every place in the Hazleton area. Shown here is the Drifton breaker, which was in the village of Drifton, south of Freeland. To the rear of the breaker is the refuse pile, commonly called a culm bank. Judging by the headgear worn by the miners shown in this image, it was made before the carbide lamp became the norm for those working underground. These miners are wearing small lamps that burned oil, which cast a yellow glow from their open flames. During the final years of underground mining in the Hazleton region, miners relied on battery-powered headlamps to light their way in the darkness. Drifton was the home of coal baron Eckley B. Coxe and his wife, Sophia.

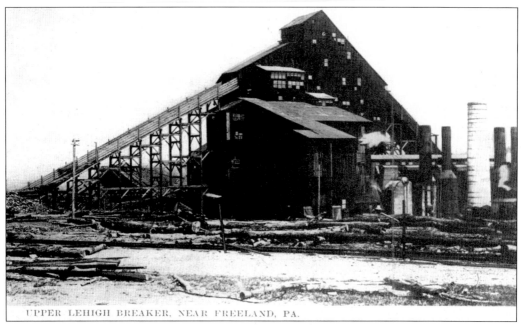

This breaker was in the village of Upper Lehigh, north of Freeland.

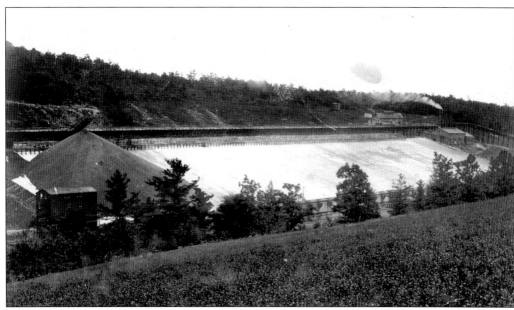

Along the Quakake Branch (later the Mahanoy and Hazleton Division) of the Lehigh Valley Railroad, Hudsondale Coal Storage started in 1905 and replaced an old storage facility at Black Creek Junction, near Weatherly. Expanded over the years, it remained important until anthracite's popularity declined. It was dismantled in 1959, and the railroad branch that served it was abandoned six years later.

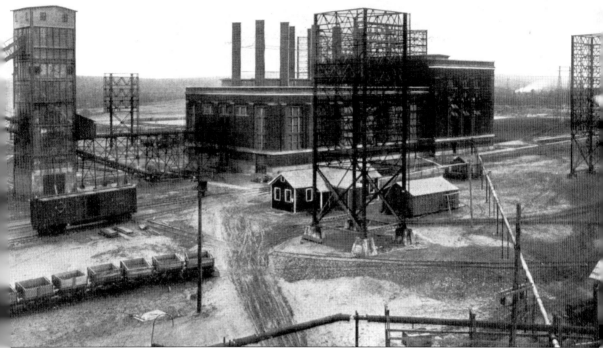

Harwood Electric Co. Plant, Hazleton, Pa.

Built originally to supply electricity to Hazleton area collieries and factories, the Harwood power station commenced operation in 1912. Through the years, improvements were made, and the facility helped give Hazleton the nickname "Power City." The plant generated power until the 1950s but was retired in 1962. The entire complex was later razed. Harwood is a patch town southwest of Hazleton and was once home to a large colliery. Industry is again a part of the village, and a large industrial park has been built in the area.

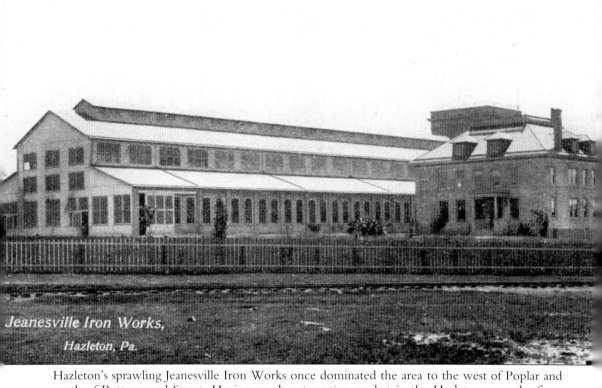

Hazleton's sprawling Jeanesville Iron Works once dominated the area to the west of Poplar and south of Buttonwood Street. Having an almost captive market in the Hazleton area, the firm, headquartered in New York City, manufactured pumps for use in the deep mining industry. The plant was closed in 1916, but many buildings remained standing. Most of the complex was razed and is now used by PPL Utilities, a local electric provider.

Four
OTHER BUSINESSES AND INDUSTRY

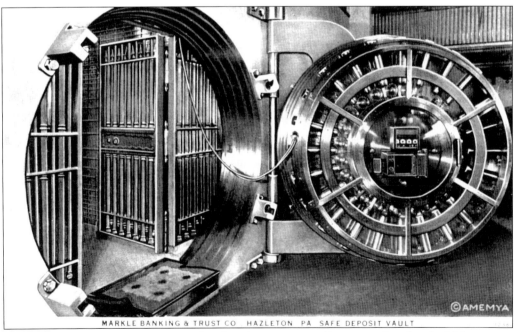

The Markle Bank Building is considered to be an outstanding example of early-20th-century construction and is found on the National Register of Historic Places. Dating from the early 1900s, the bank's original vault is at the rear of the first floor. After sitting empty for several years, the building was remodeled and is part of a reemerging downtown.

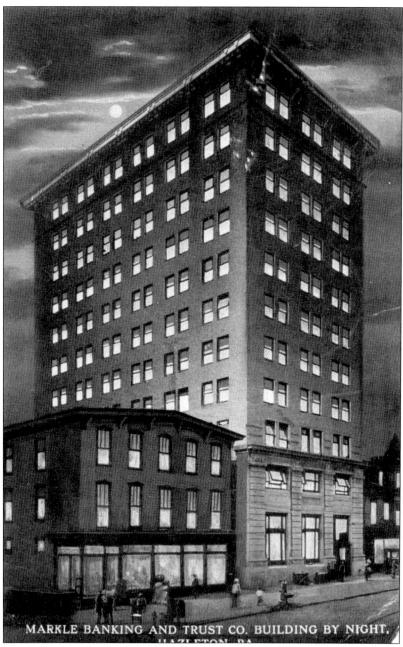

MARKLE BANKING AND TRUST CO. BUILDING BY NIGHT, HAZLETON, PA.

Hazleton's first skyscraper, the Markle Bank Building, dominated, and continues to dominate, the city's downtown. On the building's top floor was a restaurant open to employees during the day and open to the public at night. The old company store of Ario Pardee and Company, seen to the left, was razed after a fire, and a six-story addition to the bank was completed in 1923. Citing numerous problems with the building, which changed ownership several times, some thought the best thing would be to demolish the structure, opening the block for urban renewal. However, that idea was scrapped, and after the building was purchased by local businessmen, work to rehabilitate the building started. It now houses several businesses, and more are looking to locate there.

At the northeast corner of Hazleton's busiest intersection, the Altamont Hotel opened for business on July 5, 1924, with 175 rooms. It was from here that the city's first radio broadcast was transmitted in 1930. The building still stands today but has not served as a hotel since 1965. Several other businesses use parts of the structure.

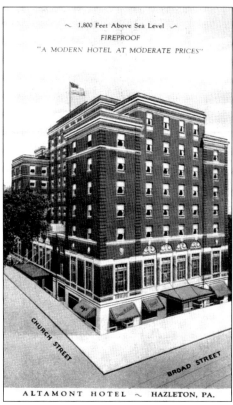

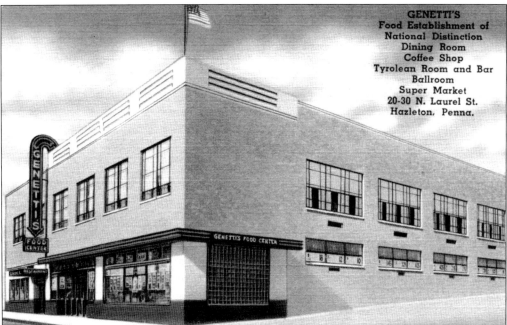

The concept of a supermarket was still new in 1939, when Genetti's opened this combination store, restaurant, coffee shop, bar, and ballroom on North Laurel Street, between Broad and Green Streets. The store has been gone for years, but the building lives on as a medical center.

In 1950, Gus Genetti opened what was then the largest motel in the area on Route 309, approximately one mile north of the city in the Hazle Township village of Milnesville. Still in operation today, the facility is a popular stop for travelers, and the banquet rooms host a wide variety of functions.

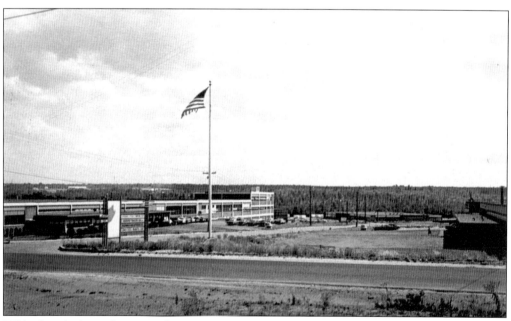

With the closing of most anthracite-mining operations in the area and few other industries available, many men who relied on black diamonds for a living found themselves unemployed. Eventually, an industrial development organization was formed to bring work to the financially stricken region. When it opened, the Valmont Industrial Park offered employment to many.

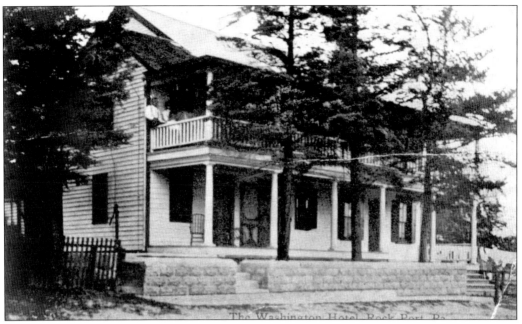

The tiny Carbon County village of Rockport was once called Grog Hollow, and it was a lumbering settlement, point on the Lehigh Canal, and terminus of the Buck Mountain Railroad. The town later became known as a health resort, and several businesses, such as the Washington Hotel, operated there. Today, the village serves as the entrance to the Lehigh Gorge State Park.

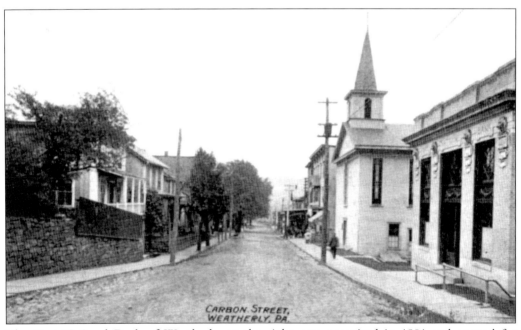

The First National Bank of Weatherly, to the right, was organized in 1901 and opened for business in the Horlacher Building the following year. The facility shown here was built at a cost of $10,000 and opened on March 30, 1907. The bank was eventually enlarged and continues to operate today, although under a different name.

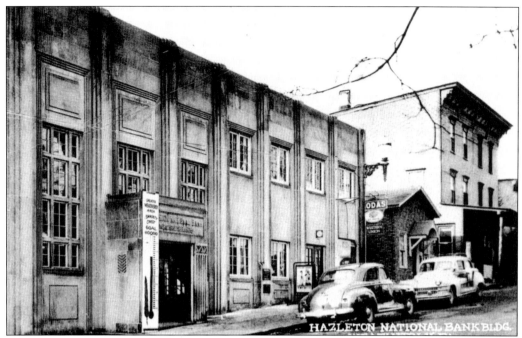

By the time this card was printed, the First National Bank of Weatherly was a branch of the Hazleton National Bank, which purchased the Carbon Street building in 1942. To the left of the entrance is a gauge showing the Greater Weatherly Area Community Chest goal of $10,000.

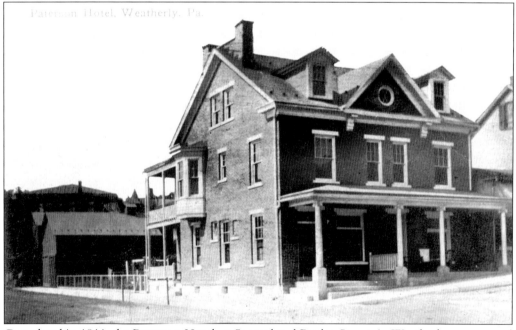

Completed in 1911, the Patterson Hotel, at Second and Pardee Streets in Weatherly, was owned and operated by Abe Patterson until his death in 1939. However, the business remained in the family and was operated by his son Robert until he retired in 1950. Today, the building houses a doctor's office and apartments.

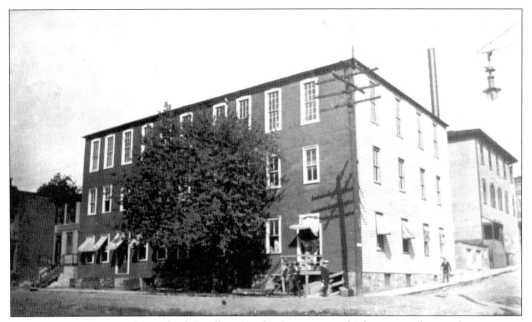

This is an early view of Weatherly's Allen Candy Company, which was on the northeast corner of Wilbur and First Streets. Having excellent rail service, the factory relied heavily on trains to transport its goods. It was reported that when a full railroad car of popping corn was popped that it could fill 12 to 15 others.

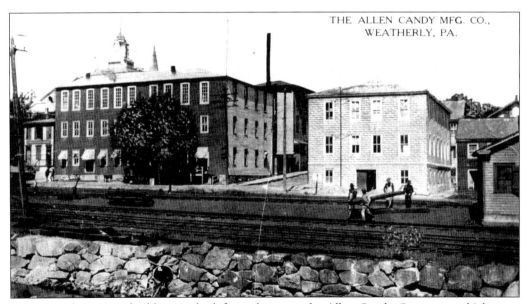

The large, three-story building to the left was home to the Allen Candy Company, which went into operation on July 10, 1899. The building to the right, built in 1906, was a warehouse for the candy factory and is still standing today on the southeast corner of First and Wilbur Streets.

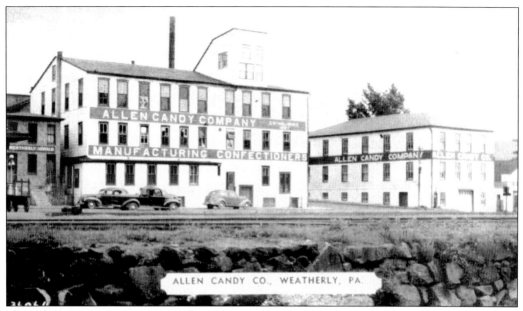

The Allen Candy Company was closed on May 1, 1949, and in 1951, Weatherly Foundry and Manufacturing purchased both buildings to house a grinding shop. The firm later moved the operations to the main plant, and the large building to the left was razed in October 1962. Shown to the left of that building was the home of the *Weatherly Herald,* which is still standing, as is the building at the extreme right.

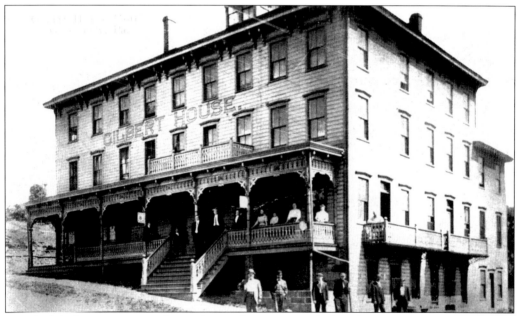

Weatherly's downtown once featured many businesses, including the Gilbert House, which was built in 1885 on the site of an earlier tavern. Through the years, it housed several businesses, including a grocery store and shoe-repair shop. The building was razed in 1983, and today a small park occupies the lot at the southeast corner of East Main and Wilbur Streets.

Ed Miller, a Weatherly photographer, was responsible for many of the early images taken of places in and around the borough. This early-1900s photograph shows the Hotel Weatherly, once a popular spot on Carbon Street. The building is still standing today, but no longer as a hotel. Its current use is for housing.

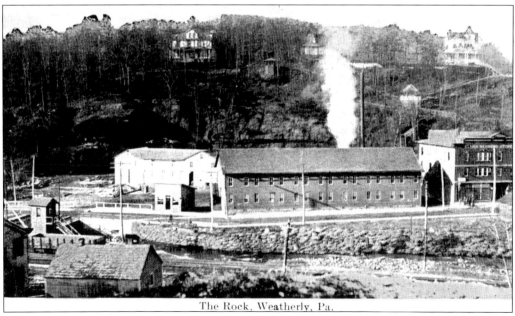

In the shadow of the Rocks, H. A. Mack Woodworking Company was in the large building in the foreground. The firm manufactured bobbins for the silk industry. The building was later home to several silk firms and the Linotype Parts Company. To the right is the Elmer Warner store. While the factory and store have been razed, the Victorian houses atop the Rocks remain standing.

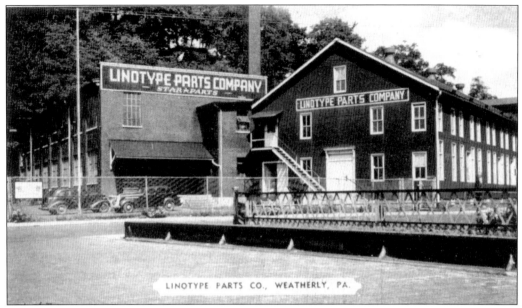

Located in the former Berlinger Silk Company building, the Linotype Parts Company produced components for machines used in the printing industry. Based here since 1947, the company changed its name to Star Parts in 1956 and moved out of Weatherly and into Hazleton in July 1967. The old building was razed, and a grocery store now occupies the site.

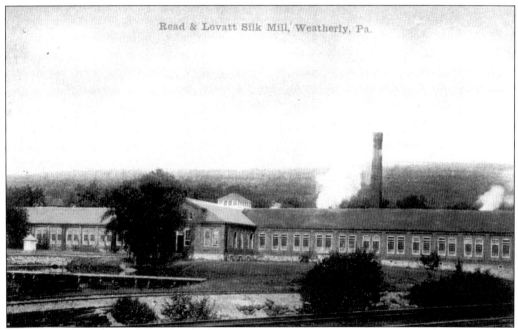

The Read and Lovatt Silk Mill was founded in 1887 at the base of Weatherly's Plane Street. With the silk industry expanding rapidly, the business continued to grow and employ many area residents. The Lehigh Valley Railroad even ran special passenger trains to transport workers to the plant. At one time, the Read and Lovatt plant was the largest throwing mill in the world.

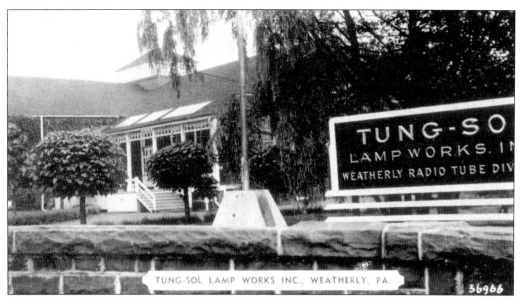

The Read and Lovatt Silk Mill became home to the Tung-Sol Electric Company in 1944, and by 1950, over 1,300 people were employed at the sprawling plant on Plane Street. The firm manufactured radio tubes until 1966, when they became virtually obsolete, having been replaced by transistors. The plant was later absorbed by the Wagner Electric Corporation, which also closed.

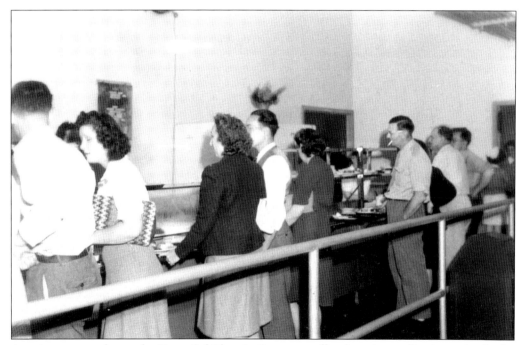

A major area employer, the Tung-Sol Electric Company offered workers cafeteria service in the former silk mill it was located in. On January 23, 1953, the plant hit the million mark in radio tube production, and the firm expanded the building twice from 1956 to 1960. The building's future is uncertain today.

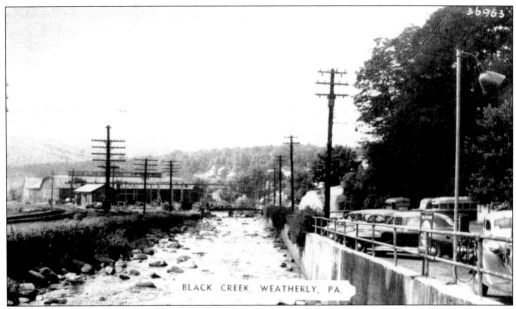

Flowing toward the Lehigh River, Black Creek is seen here along Weatherly's Hudsondale Street. In the background to the left is the former Lehigh Valley Railroad shop complex, which became home to the Weatherly Iron and Steel Company in 1912. Also shown is the little red footbridge that created a shortcut for those living in the town's west side by spanning the creek.

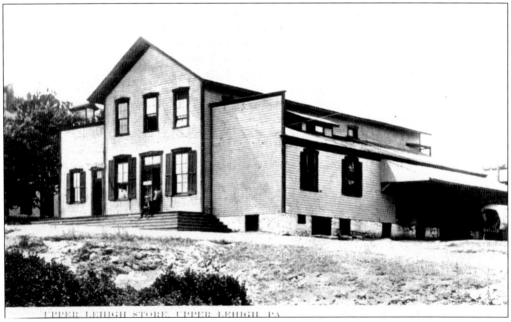

Upper Lehigh differed from typical coal towns in that it was designed with broad streets, and the many houses constructed by the company were all painted. It was reported that the town was very clean, and no trash was permitted in the streets or alleys. The company store of the Upper Lehigh Coal Company is shown here as it appeared in the early 1900s.

Five
Schools

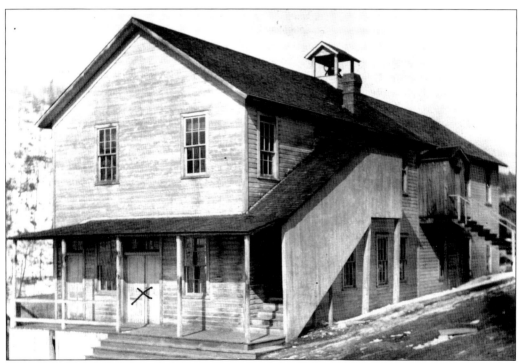

Before schools were consolidated into larger buildings, they could be found in almost every neighborhood. Although the exact location could not be determined, this school was in Hazleton, which at one time had over 30 separate educational facilities. The two-story frame school may have stood in the city's southeastern section.

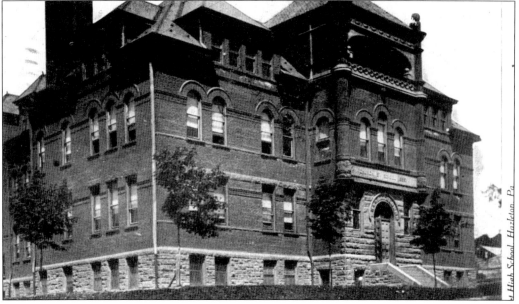

As 1900 approached, Hazleton continued to experience a population explosion, and outdated schools were replaced. The Church Street School was built in 1896 on the northwest corner of Church and First Streets. The large structure was destroyed by fire 22 years later. The D. A. Harman School, named in honor of former superintendent David A. Harman, was built on the site in 1921.

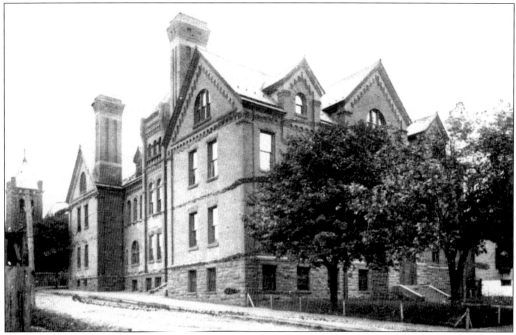

Located on the northwest corner of Laurel and Green Streets, the Green Street High School was built in 1891 on the site of an earlier school. When classes were moved to another building, the district housed its offices in the stately brick building. It was razed in 1981, and the site is now a parking lot.

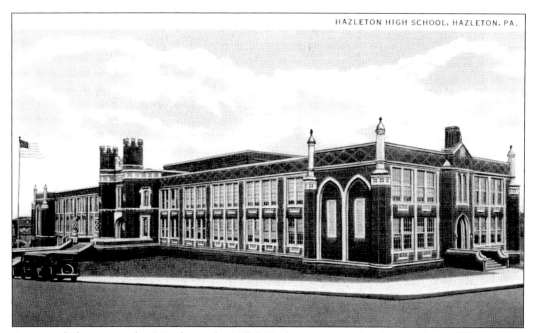

Commonly known as the "Castle on the Hill," Hazleton High School opened in 1928 on North Wyoming Street. A state-of-the-art educational facility when constructed, it served the community until its closing in the 1990s. Due to an increasing population, the Hazleton Area School District is planning to once again utilize the landmark structure.

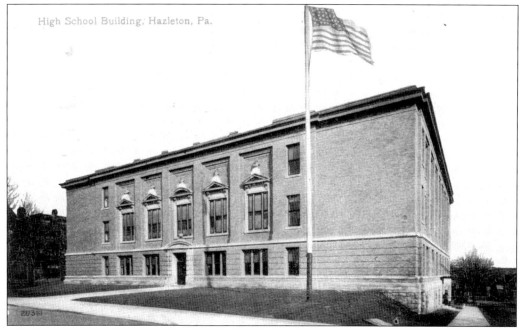

An increase in population necessitated the construction of larger schools. The Vine Street High School was built in 1912 to replace the Green Street High School. The school was later renamed the H. F. Grebey Junior High School. After being closed and sitting vacant for several years, the building was razed.

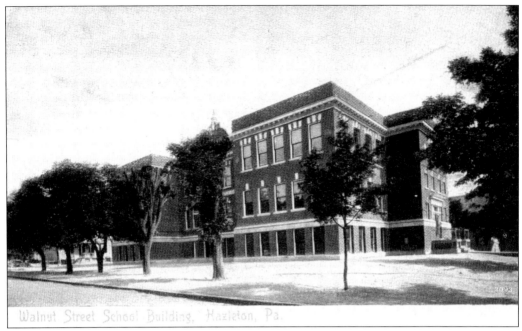

Coal was responsible for Hazleton's growth, and as the population swelled with new workers coming to the area, the need for better educational facilities became obvious. In 1905, the brick Walnut Street School was built on the site of a former frame school building. This school was destroyed by fire in 1950.

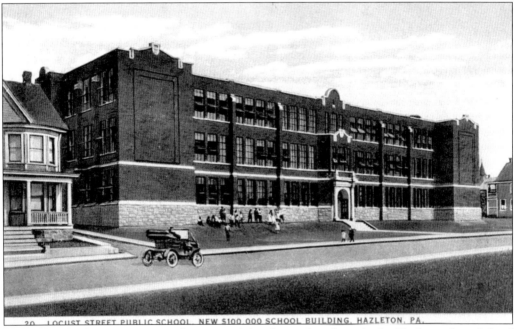

Built in 1915, the Locust Street Elementary School served students in the Hazleton Area School District for many years. When a larger school was constructed, the Locust Street School was closed. However, in the 1990s, the building was sold and remodeled, and it continues to be used for education as the Immanuel Christian School.

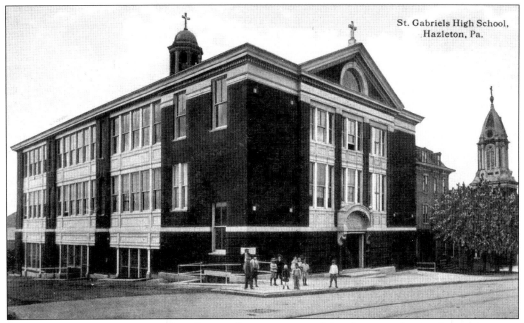

Originally established in 1874 on the northwest corner of South Wyoming and Birch Streets, St. Gabriel's High School experienced steady growth, and this modern brick school was completed in 1911. As more and more residents opted for a parochial education, a new wing was added in the 1950s. After serving the community for years, it was razed in 1999.

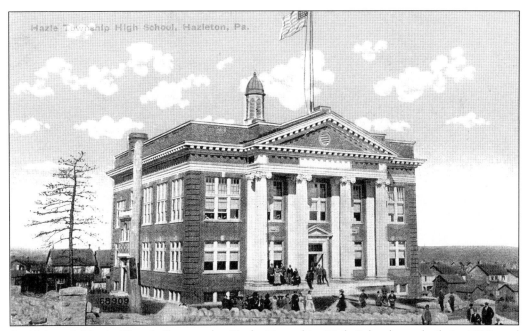

At 13th and North Church Streets, the Hazle Township High School was built in 1910, and classes were last held there in 1965, when students were sent to other schools of the Hazleton Area School District. Unlike many other old schools, this building has been remodeled and continues to see use by a local hospital.

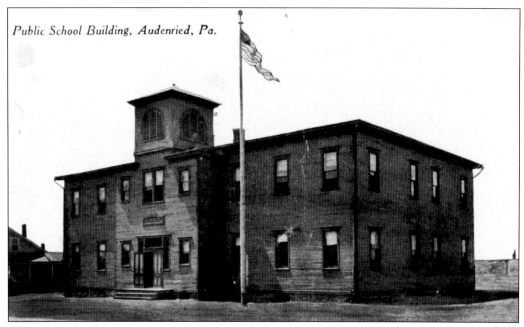

Like most schools in the smaller coal towns, the two-story Audenried Public School was of frame construction. This building contained eight grades and remained open until the late 1940s. The size of this school is a testament to the population Audenried once had, and another large school was located in the adjoining village of Beaverbrook.

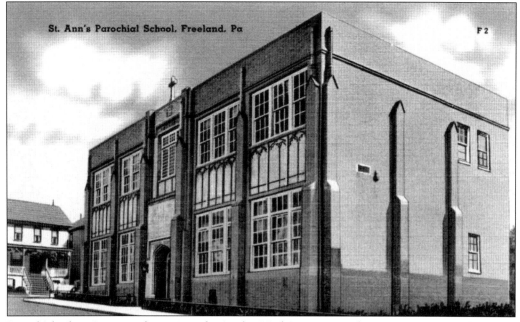

Parochial education was always popular in the Hazleton area, and many parents opted to send their children to schools offering a Catholic-based education. St. Ann's School, on the corner of Ridge and Chestnut Streets in Freeland, was built in 1929. St. Ann's High School was closed in 1966, and the elementary school stopped offering classes in 1971.

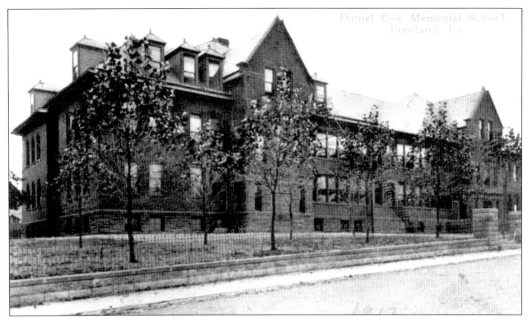

Instead of "Cox," the spelling on this card should be "Coxe." Established in 1896, Freeland's Daniel Coxe Memorial School was at Chestnut and Washington Streets. Through the years, the facility experienced an increase in students, and an addition was built in 1913. The school was later closed and demolished.

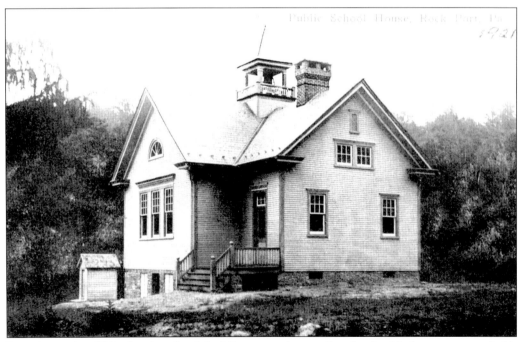

Less than a handful of early school buildings remain standing in the Hazleton area, and this structure in the Carbon County village of Rockport is probably the best-preserved example. The building is located on the main street leading into the village and is home to the Flying Aces Motorcycle Club.

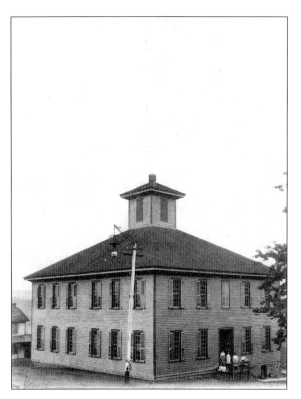

On a knoll above the town's business district, Weatherly's Oak Grove Seminary School was a public educational facility that was built in 1869 on the site of an earlier school building. After the Mrs. C. M. Schwab School was completed, the old school was razed, and the Monument Grounds were built in its place.

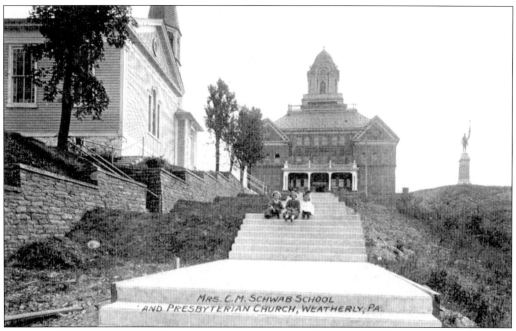

The steps leading from East Main Street to Spring Street are still in place today. When the Mrs. C. M. Schwab School was open, the steps were used primarily by those walking to and from school. To the left is the Weatherly Presbyterian Church, and the Civil War monument is visible to the right.

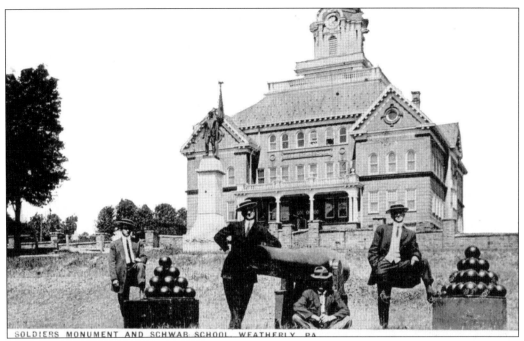

Four unidentified men pose around the cannon on Weatherly's Monument Grounds, site of the former Oak Grove Seminary School, which had been razed several years before. Fronted by Spring Street, the landmark Mrs. C. M. Schwab School is to the rear. The cannon and monument to Civil War soldiers are still in place.

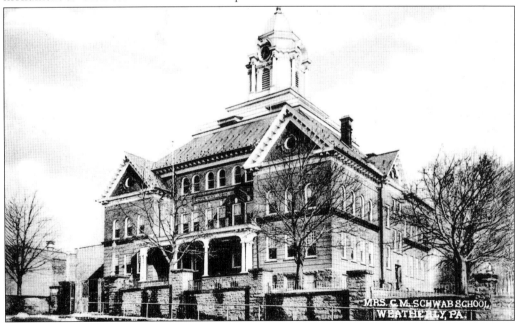

The Mrs. C. M. Schwab School was a gift to the people of Weatherly from millionaire industrialist Charles M. Schwab. Completed in July 1903, the $75,000 structure served the educational needs of the community until a new high school was built at Evergreen Avenue and Sixth Street. Still a landmark, the former school sits empty and with minimal maintenance.

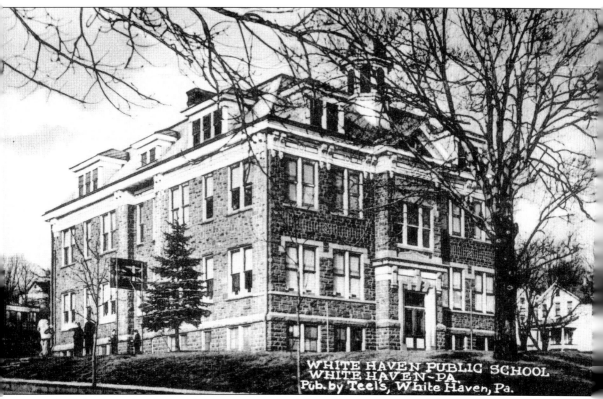

Built in the early 1900s, this large, stone school in White Haven served the community until the mid-1970s, when educational needs in the borough were absorbed by the Crestwood School District. After sitting abandoned, the school, located between Wilkes-Barre and Buffalo Streets, was converted into an apartment building. It was the third school to be built in White Haven. Through the years, many schools that served local communities were abandoned, and most were eventually torn down. Weatherly's Mrs. C. M. Schwab School remains standing but vacant. Turning schools into apartments is not a cheap proposition, but it is an excellent way to preserve the historic buildings that provided education to so many through the years.

Six
CHURCHES

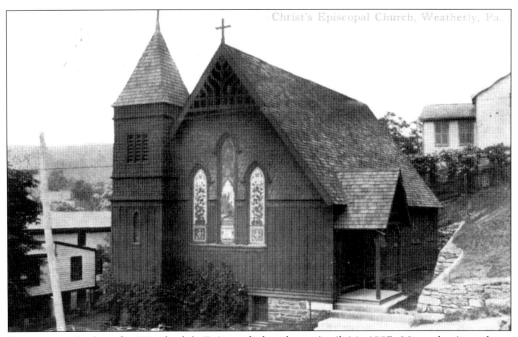

Ground was broken for Weatherly's Episcopal church on April 16, 1887. Never having a large congregation, the church originally consisted of 21 members. Growth was not destined to happen, and the church was closed in 1918. The building remains standing on East Main Street, at the north end of Carbon Street, and it is called the Church Apartments.

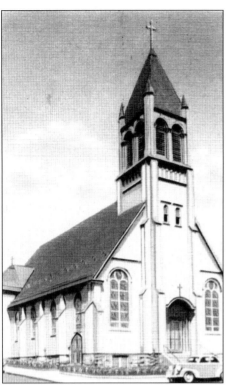

Hazleton's Holy Trinity German Catholic Church traces its history back to 1887, when it was established to meet a growing population of German immigrants. Those seeking to build the church at Laurel and Oak Streets raised half the money for construction, and it was dedicated in 1887. Today, it is known as Holy Trinity Roman Catholic Church.

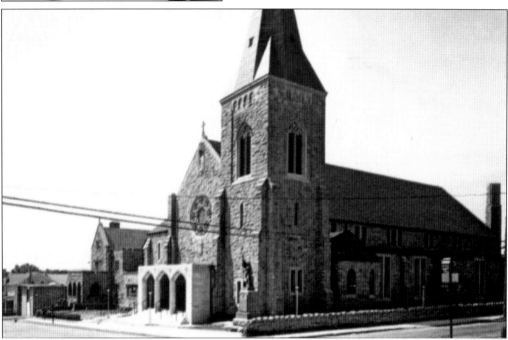

St. Joseph's Roman Catholic Church, on Hazleton's North Laurel Street, is a true survivor after being hit by two major fires in its 122-year history. The original frame edifice was destroyed by fire in 1905 and was replaced with the present stone building. On March 1, 1963, a $1 million fire struck the church, which was rebuilt and continues to operate today.

Hazleton's Grace Reformed Church, on North Laurel Street, is still standing, but it is no longer used as a house of worship. After the congregation merged with three others in the 1990s, a local theater for the performing arts found a home in the large building, which sits on the east side of the street.

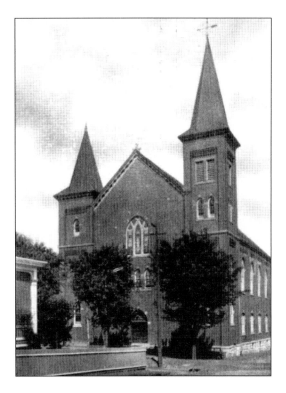

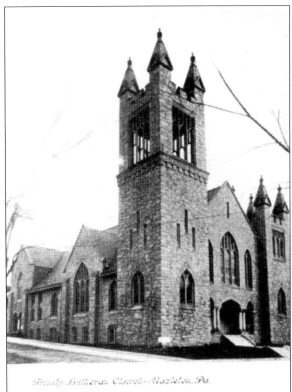

Trinity Lutheran Church, at Church and Hemlock Streets, dates from 1874, and the cornerstone for the present house of worship was laid on August 7, 1904. The sanctuary was renovated and dedicated in July 1974 by Rev. Byard J. Ebling. Only six pastors served the congregation during the church's long history in Hazleton.

73

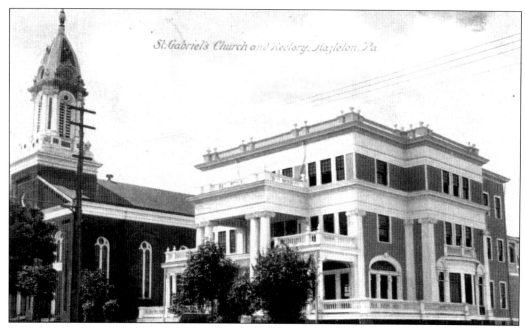

St. Gabriel's Church, on South Wyoming Street between Chapel and Beech Streets, was started in a small, frame structure erected in 1856. In this view is the second church, built of brick. Mass was celebrated in this church until 1924, when construction began on a larger church to serve a growing parish.

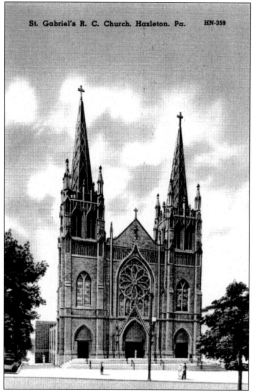

At the time of its establishment in 1856, St. Gabriel's was actually a mission church of St. Mary's in nearby Beaver Meadows. As the Hazleton congregation grew, St. Mary's later became a mission of St. Gabriel's Church. This view from the 1940s shows the church as it appears today.

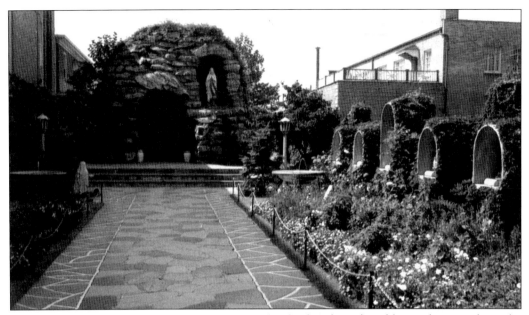

Founded in 1885, Hazleton's Most Precious Blood Church is the oldest Italian parish in the Diocese of Scranton. Located at the intersection of Fourth and Seybert Streets, the church features a grotto and fountains, which are made of Rosso-Rubino marble from Italy. The grotto attracts visitors from throughout the country.

This shrine to the Blessed Mother and the church, to the left, were immortalized on a c. 1906 real photo postcard. The image could have been made at one of several churches in Hazleton, where the card was mailed at nine a.m. on October 9, 1906. According to the postmark, it arrived in nearby Eckley later that day.

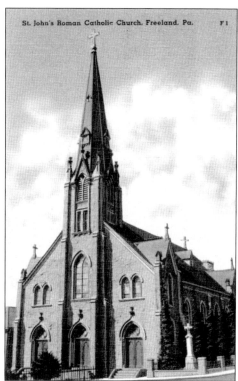

St. John Nepomucene Roman Catholic Church dates from 1889, when the Freeland parish's first house of worship was built at Ridge and Luzerne Streets. The parish had grown considerably, and the church shown here, at Vine and South Streets, was completed in 1917, when Rev. Joseph Korman was serving as pastor.

Along Route 940 in Harleigh, just north of Hazleton, is the Shrine of the Sacred Heart, reported to be the largest outdoor shrine to the Sacred Heart in North America. In its earlier years, Harleigh was a coal town typical of the region. The breaker, one of the last in the region, was torn down in the late 1990s.

Built in 1850, St. Joseph's Church was located along Church Road in Lowrytown. Several stones in the cemetery date from the 1850s, and it is very possible that some were removed. When the church closed in 1957, parishioners attended St. Nicholas Church in Weatherly. This church was destroyed by fire on October 17, 1967.

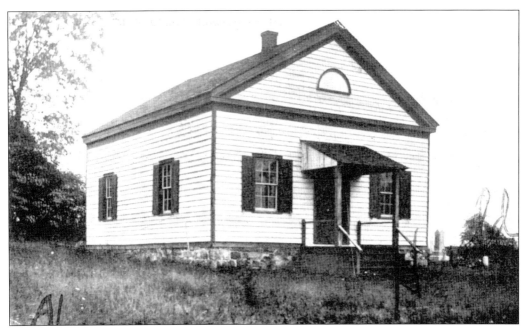

Lowrytown's Methodist Episcopal Church was tiny by today's standards, but it served a congregation made up of residents from both Rockport and the fertile Lowrytown Valley. The church has been gone for many years, but the cemetery is a well-maintained place in this very rural part of Carbon County.

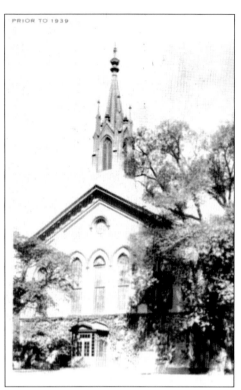

Hazleton's First Presbyterian Church dates from 1838, and in its early years, the members met at the combination church and school, which was then at the corner of Church and Green Streets. Built in 1854, this church is on the northwest corner of Church and Broad Streets and continues to serve a large congregation.

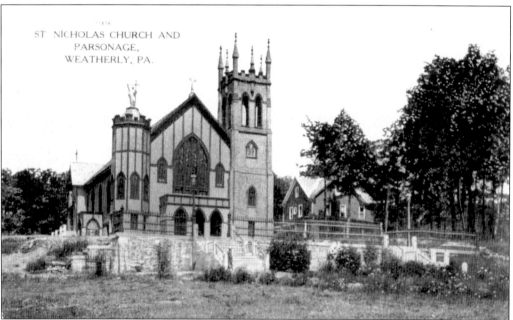

Weatherly's St. Nicholas Roman Catholic Church, on Plane Street, has enjoyed a long history in the borough since being dedicated in 1874 as a mission of St. Joseph's Church in Lowrytown. This building was constructed in 1907 and has been remodeled several times. The rectory, to the right, burned in 1950, and another was constructed of stone and brick in the same place as the original.

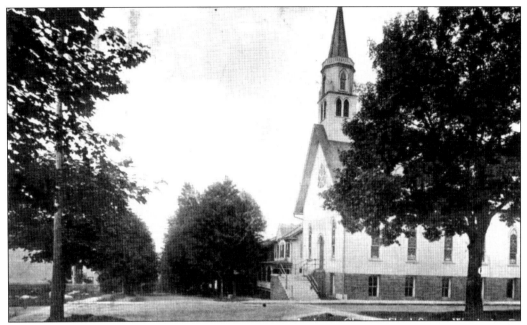

On the northwest corner of Third and Fell Streets, Weatherly's Lutheran congregation originally met in the First Presbyterian Church and later at a private home. Land for the church was purchased from Asa Packer, and this building was dedicated on September 10, 1876. The building was remodeled in 1904 and is now known as Zion's Lutheran Church.

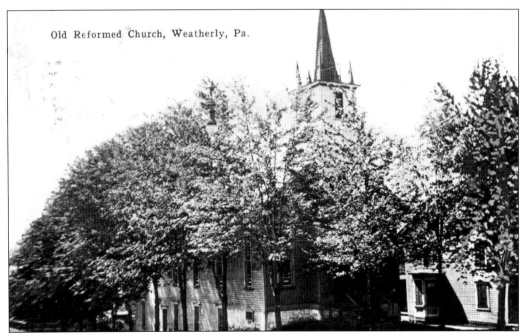

Built on land donated by railroad magnate Asa Packer, Weatherly's Salem Reformed Church was organized on January 4, 1876, and the building's cornerstone was laid on April 30 of that year. At the southwest corner of First and Fell Streets, this wood-frame church was razed in 1914 to make room for a new house of worship.

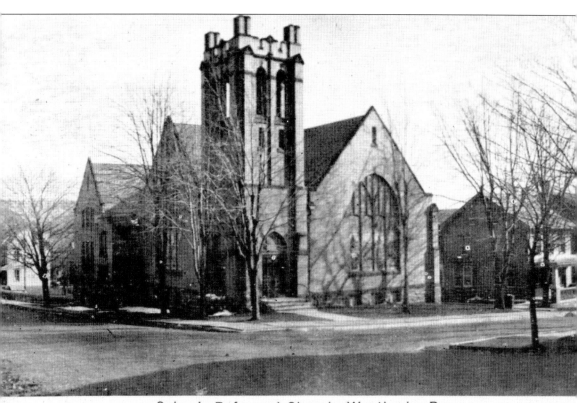

Salem's Reformed Church, Weatherly, Pa.

Salem Church was built at a cost of $23,000 on the site of Salem Reformed Church. Weatherly's Salem United Church of Christ, constructed of brick and stone, was dedicated in 1916. During the time it took to construct the new church, the congregation met in the Warner and Wass Hall on West Main Street.

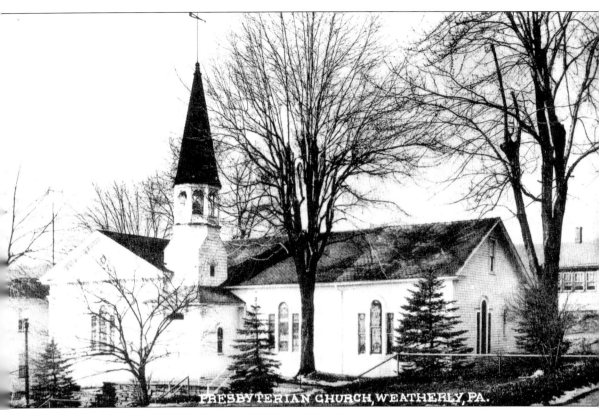

Dating from 1853, Weatherly's First Presbyterian Church, on Spring Street, is the oldest church building in the Hazleton area still in continuous use. At its height, the congregation counted 167 members. An addition was built in 1928, and a remodeling project was completed in 1961. Presbyterian services in Weatherly trace their origin to 1838, when a minister traveled to town once a month from a church in Beaver Meadows.

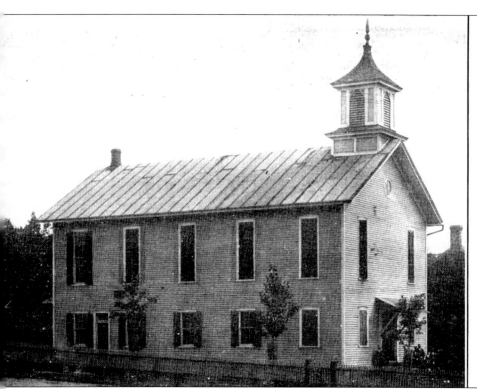

First Presbyterian Church
Upper Lehigh, Pa.

The Upper Lehigh Presbyterian Church was organized on June 28, 1868, with this building being constructed in 1871 at a cost of approximately $4,500. The church was founded by Presbyterian members of the Upper Lehigh Coal Company, and when the mines went into operation, churches were quickly established. This was one of two churches in the village, the second being a Welsh Baptist church organized in 1868. Churches were important places in the coal towns, and virtually everyone attended Sunday morning services. Commonly, the buildings were also used for social events that gave families a break from the daily grind of life in a colliery town.

Seven
PUBLIC AND PRIVATE BUILDINGS

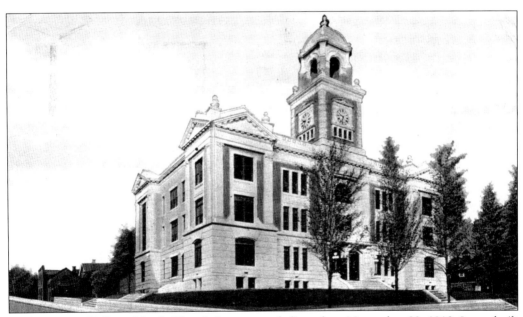

Hazleton City Hall, on North Church Street, was dedicated on November 22, 1912. It was built on the location of a former structure that was the growing city's first church and school, donated by pioneering coal operator Ariovistus (Ario) Pardee. The interior of city hall contains marble staircases and trim with brass handrails.

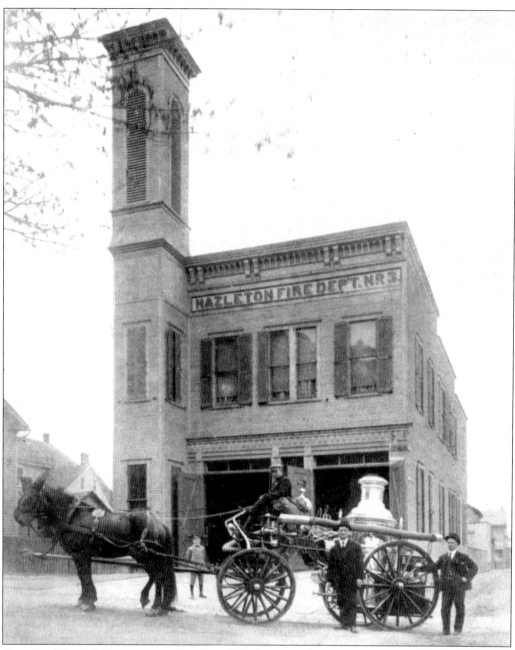

Organized firefighting came to the city of Hazleton in the mid-1800s, and the East End Fire Company, originally located at Poplar and Chestnut Streets, was founded in 1894. The East End Fire Company eventually moved to modern quarters on East Broad Street. Through its many years of service, the Hazleton Fire Department responded to thousands of calls and many major fires. Some blazes of note involved the Palace Theater, on Wyoming Street, and the Capital Theater, on Broad Street; in 1939, the former Alton Theater was destroyed by fire. In early December 2004, the six-story former Rinehart's Furniture building, on East Broad Street, was destroyed. The structure was one of the oldest buildings still standing in Hazleton. The city is now protected by five companies with full-time, paid drivers.

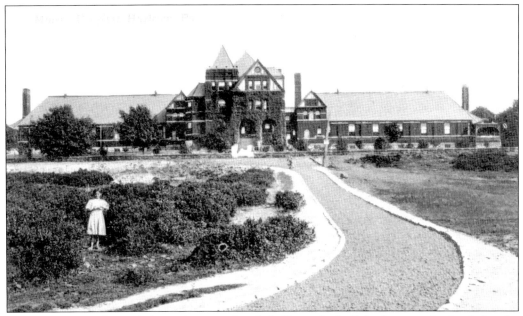

Hazleton's Miners' Hospital was the second such facility to be built in the area, the first being the Drifton Hospital, near Freeland. A tiny facility, the Drifton Hospital had four wards and could accommodate a maximum of 14 patients. It was primarily used to treat miners who were injured while working.

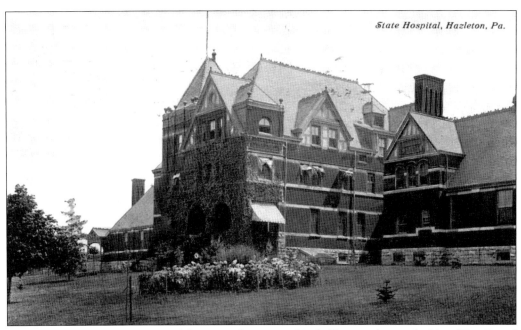

Officially called the State Hospital for Injured Persons, this facility, on the south side of East Broad Street, opened in 1889 and was considered to be a state-of-the-art hospital. In 1975, a new, seven-story, 200-bed hospital opened on this site to replace the old building, which contained 119 beds. The state no longer controls the facility, known as Hazleton General Hospital.

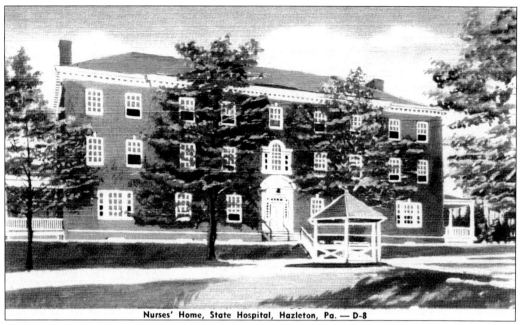

Nurses' Home, State Hospital, Hazleton, Pa. — D-8

Along with treating and caring for patients, the Hazleton State Hospital was a teaching facility where many trained to become registered nurses. Although the old hospital building was torn down and replaced in the 1970s, the nurses' home remains standing but is now the location of a mental health care provider.

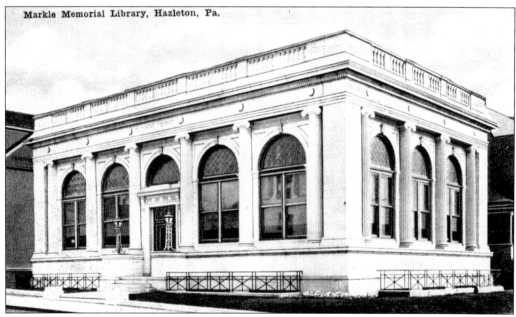

John Markle was a notable Hazleton resident, and in 1912 he gave the city, in memory of his parents, what was known as the Markle Memorial Library. The building, at the southeast corner of Church and Green Streets, is today the Hazleton Public Library. The first library came to the city in 1907, when a facility containing 4,111 books opened in the Junior Mechanics Hall on West Broad Street.

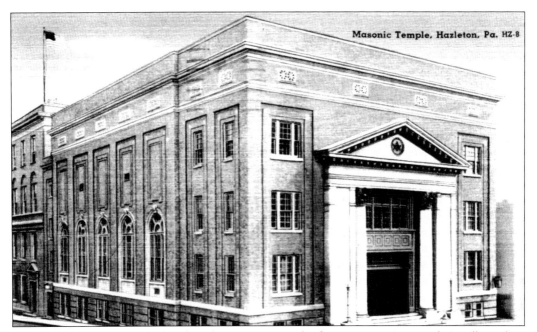

At the southeast corner of Church and Green Streets, the former Masonic Temple is still standing but today sees another use. In the 1970s, the large building was purchased and remodeled by the city's Holy Trinity Church and is now used as a parochial school.

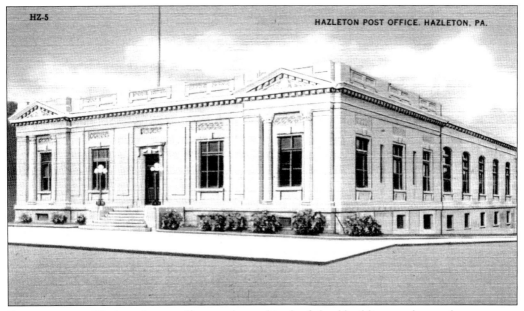

For many years, Hazleton's post office was located in the federal building on the northwest corner of Broad and Cedar Streets. Later, the post office relocated to a new building on Wyoming Street, on the site of the former Duplan Silk Mill's girl's club. Today, the former post office is occupied by county offices and the chambers of the local district justice.

An institution in the city, Hazleton's YMCA was organized on January 29, 1914, and was located on West Broad Street. A new facility (now a YMCA and YWCA) on South Church Street was dedicated on October 18, 1964, and continues to operate there. In recent years, the building underwent a modernization and improvement project. Along with a swimming pool and exercise equipment, the facility now features a climbing wall, which simulates rock climbing in an indoor, controlled environment.

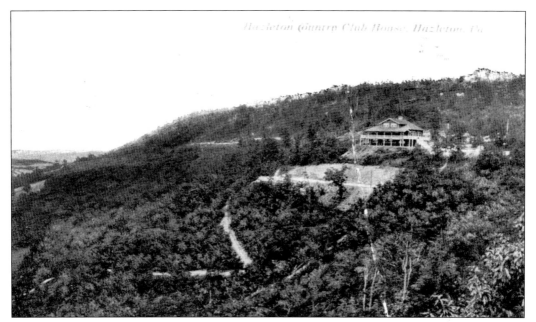

The history of the Hazleton Country Club, north of Route 93 at the top of Conyngham Mountain, dates from the early 1900s. A new facility was built later, and the club remains a popular and active place.

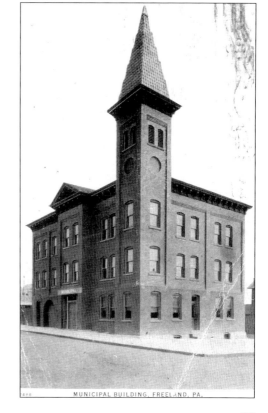

Once known as Freehold, Freeland was incorporated as a borough in 1876. Although the borough building has been slightly altered from when this image was made in the early 1900s, municipal business continues to be conducted there, and it is still home to the local fire company.

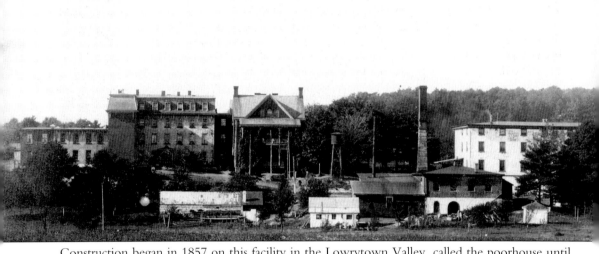

Construction began in 1857 on this facility in the Lowrytown Valley, called the poorhouse until 1925, later the District Home, and later still the Carbon County Home. The complex was built on 315 acres of farmland and housed or distributed aid to the needy in both Carbon and Luzerne Counties. In 1894, Eckley B. Coxe donated $2,000 for the construction of a new hospital, and in 1892, the facility's first nurse came from Philadelphia to Lowrytown. Eckley's wife, Sophia, paid half of the nurse's salary. Known until 1944 as the District Home, the complex was renamed the Carbon County Institutional District Home and then the Carbon County Home in 1906. A new home, then called Weatherwood, was dedicated in 1972. Located in Weatherly's east side, the facility is now officially called Weatherwood–Carbon County Nursing and Rehabilitation Center.

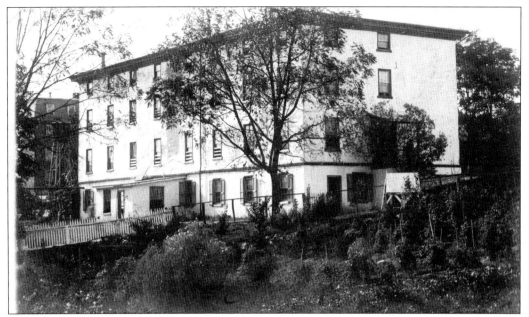

Not a single building of Lowrytown's county home remains standing. After the new county home was constructed in Weatherly, the buildings and land at the old facility were sold to a utility company. The complex was razed in 1978, and the only thing to mark its location is a cemetery, commonly called "Potter's Field."

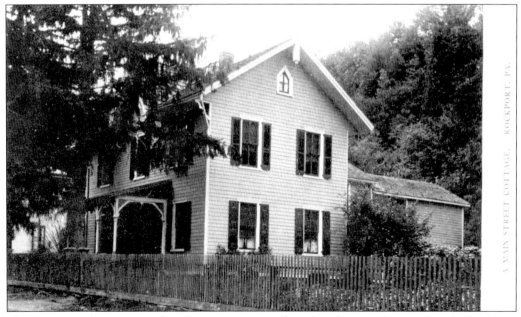

This two-story house was referred to as a cottage when the photograph was taken in Rockport c. 1906. Once called Grog Hollow, Rockport was a point on the Lehigh Canal and later became known as a health resort. The village is now best known as a point in the Lehigh Gorge State Park where rafting trips originate on the Lehigh River.

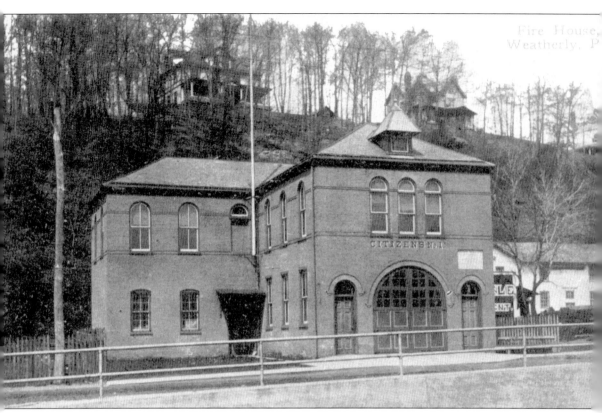

Firefighting in Weatherly dates from 1892, when the Florence Hose Company was established. This Hudsondale Street firehouse was built in 1893 and also housed the borough offices. Florence Hose was later disbanded, and a new charter was granted to Citizens Fire Company No. 1 on July 15, 1901. In 1976, the fire company moved to new quarters at Spring and Laurel Streets. After the fire company vacated the building, the Greater Weatherly Ambulance Association located in the building until a new ambulance station was built on Carbon Street. The Citizens Fire Company No. 1 continues to serve Weatherly and the surrounding area with well-trained personnel and modern firefighting equipment. The old firehouse is now an auto body shop and part of Warner's Central Garage.

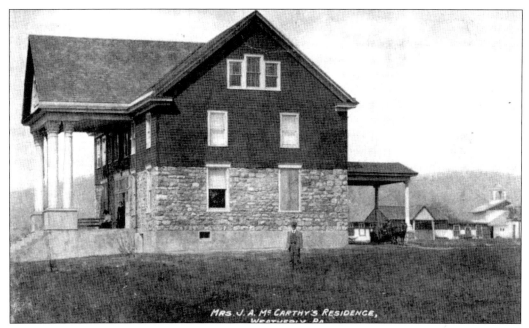

Weatherly's Justin McCarthy house, in the western end of the borough, was built by in 1906 by John McCarthy, a former Hazleton newspaper editor. It contained 16 rooms and 4 bathrooms. It was later occupied by John's son Justin, who was an area huckster and painter, and his works have been displayed in New York's Metropolitan Museum of Art.

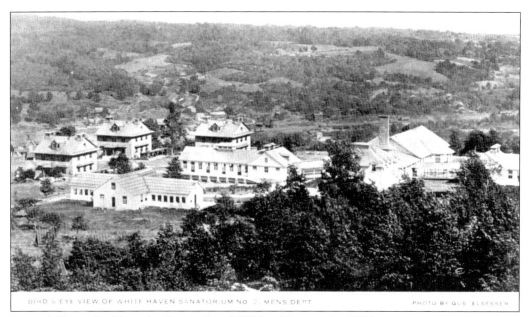

On a hill overlooking the borough of White Haven, the White Haven Sanatorium was established by Dr. Lawrence F. Flick for the treatment of tuberculosis. It was believed that the clean mountain air helped cure those who suffered from the disease. After experiencing many fires since its closing, the entire complex was razed.

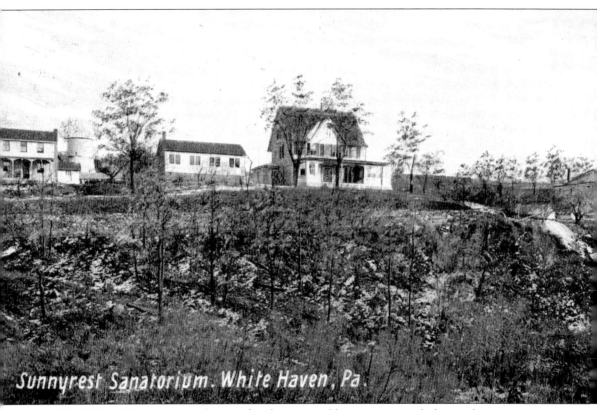

Sunnyrest Sanatorium. White Haven, Pa.

The White Haven area was known for clean air and became a natural place to locate sanatoriums for those suffering with tuberculosis. The Sunnyrest Sanatorium was across the Lehigh River, in East Side Borough. Closed after a vaccine for the disease was developed, many buildings are still standing and are used as private homes.

Eight
Transportation

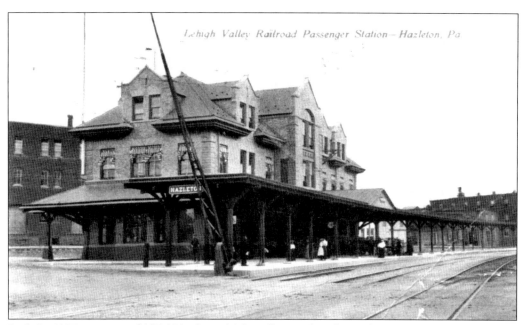

Built in 1907 at a cost of $95,000, the Lehigh Valley Railroad's Hazleton station was considered one of the most ornate buildings in the city. Passenger service ended in 1961, and the station was demolished two years later. Today, the site between Church and Laurel Streets is a parking lot.

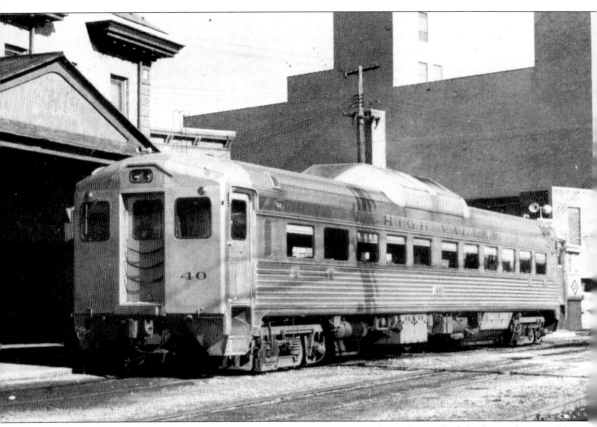

The era of railroad passenger service in Hazleton was approaching the end of the line when Budd Car No. 40 was photographed at the city's Lehigh Valley Railroad station, located on Mine Street. Rail Diesel Cars (RDCs) such as this carried passengers to and from Lehighton, where connections could be made for other points on the system. All passenger service on the Lehigh Valley Railroad was suspended on Friday, February 4, 1961, when during a snowstorm RDC No. 41 made the final passenger run on from Hazleton to Lehighton, passing through the borough of Weatherly. In earlier years, virtually everyone who needed to travel distances purchased a ticket and left from Hazleton to anywhere in the country, and many passenger trains served the city each day. These early steam trains transported the thousands of immigrant coal miners who came to the region for work.

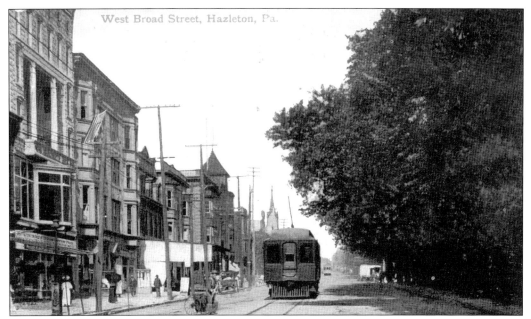

Like most cities, Hazleton developed a strong public transportation system early on, and regular trolley service was common. In later years, buses replaced trolleys, and they continue to serve the city and outlying town today. This scene, from c. 1905, shows Broad Street, between Laurel and Church Streets. The wooded area to the right is the southern edge of Pardee Square.

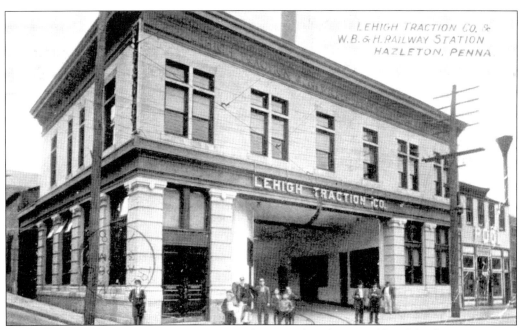

The Lehigh Traction Company was organized in 1892 by Alvan Markle of the famous coal and banking family. The company also owned the Wilkes-Barre and Hazleton Railway, which operated electric trolleys between the two cities. The main Hazleton station was on North Wyoming Street, between Church and Green Streets. The site is now a parking lot.

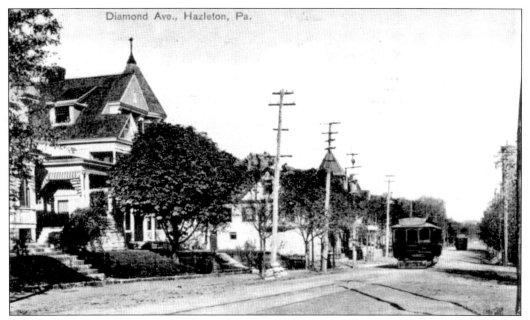

Two trolley cars can be seen in this early view of Hazleton's Diamond Avenue. In the years before cars became the norm, people commonly used some form of rail service; trolleys for local trips and passenger trains for more distant destinations. With the exception of large cities, trolley service ended as automobiles gained popularity.

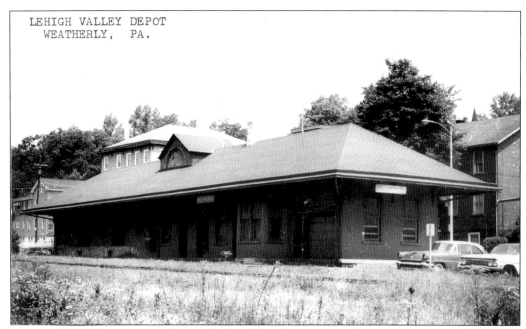

Opened on March 27, 1889, the Weatherly railroad station served the community until a decline of freight prompted the Lehigh Valley Railroad to close the facility in March 1970. At the height of passenger operations, 22 trains stopped here each day. The borough purchased the building in 1973, and today it houses the borough offices.

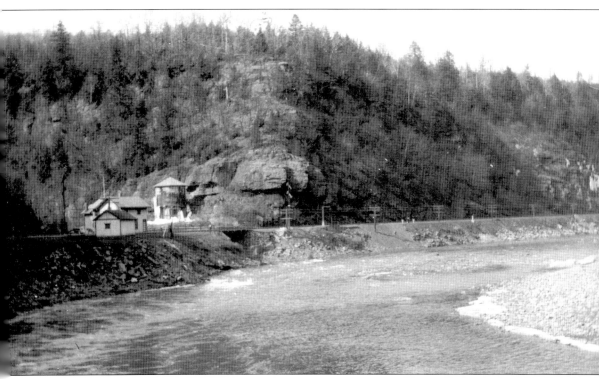

Deep in the famous Lehigh Gorge, Rockport's New Jersey Central Railroad station was on the west bank of the wild and scenic Lehigh River. In addition to the village of Rockport, the station also served the nearby poorhouse in Lowrytown. The old railroad grade, one of two running through the gorge, is today a hiking and biking trail, although the former Lehigh Valley Railroad is still in use on the east side of the river and passes through the Rockport Tunnel. In the early 1990s, the Hazleton City Authority constructed a pumping station, which is to the extreme left. Water is pumped from the Lehigh River, and after filtration it is distributed to authority customers in Hazleton and other towns.

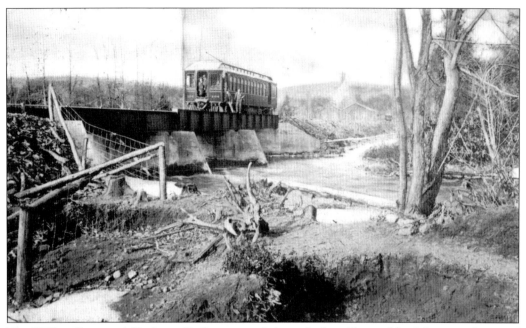

The Wilkes-Barre and Hazleton Railway passed through the village of St. Johns, northwest of Hazleton. The line relied on a protected third rail to power its trolleys. It was near here that the route experienced a serious accident in May 1928, when two trolleys hit each other head-on. A fire broke out, and the motorman of the northbound trolley was trapped and burned to death.

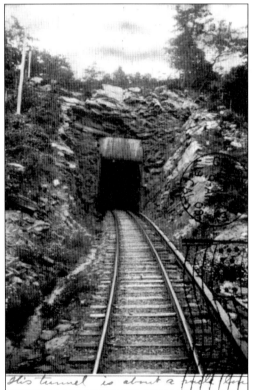

Some believe this tunnel of the Wilkes-Barre and Hazleton Railway was cut through Penobscot Mountain, south of Wilkes-Barre. However, it is probably north of the Penn State Highacres campus, and a portal can be seen from Interstate 81. The sender of this card in 1908 wrote that the tunnel was a mile long and he passed through it on his way to work in Wilkes-Barre.

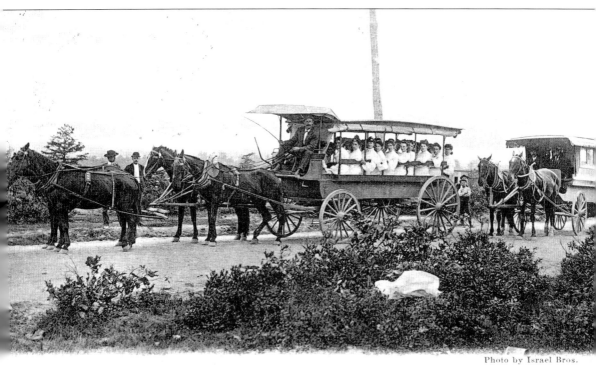

J. F. Horn's Stage Coach Line, running between Beaver Meadows and Hazleton, Pa.

Although Beaver Meadows was served by a branch of the Lehigh Valley Railroad, trolley service from Hazleton did not reach that far east. This view, from approximately 1905, shows the J. F. Horn Stage Coach Line, which operated between Beaver Meadows and Hazleton. As in most places, public transportation was necessary, and as time went on, early forms of bus transportation began to operate between Beaver Meadows and the city.

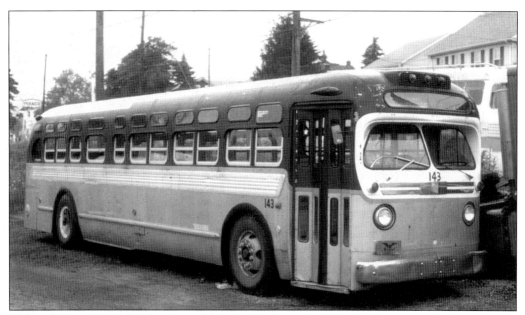

Although identified as being photographed in Hazleton in 1984, this bus was probably parked in nearby Beaver Meadows. Bus service had replaced the trolleys, and today the city continues to see public transportation provided by Hazleton Public Transit, which provides bus service not only in the city but to outlying towns as well.

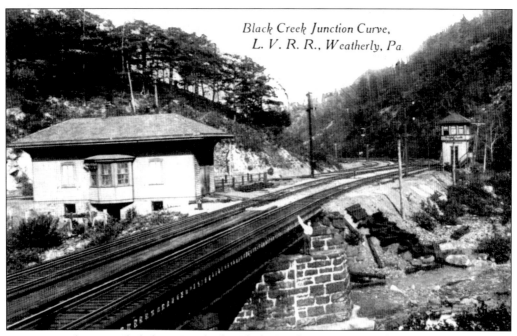

Approximately one mile below Weatherly, Black Creek Junction was the meeting point of the Hazleton and Quakake Branches of the Lehigh Valley Railroad. In its earlier days, the site was also home to a small coal-storage facility. The tower was closed on December 31, 1931, and the Quakake Branch, then known as the Mahanoy and Hazleton Branch, was abandoned in 1965.

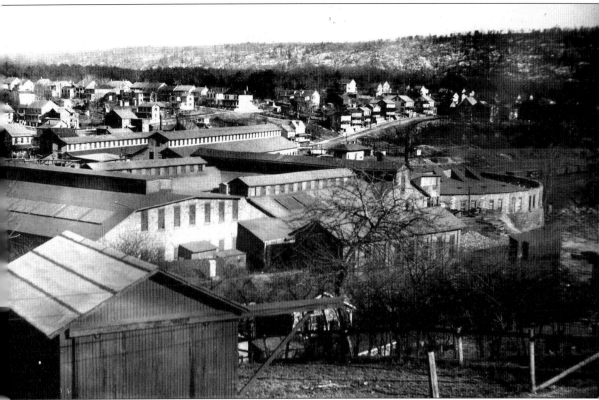

The Lehigh Valley Railroad's Weatherly roundhouse, in the right foreground, was built in 1866 and contained 16 locomotive stalls. After being abandoned in 1920, decay set in, and the building was razed nine years later. The stones from the huge structure were used to line the nearby Black Creek. The buildings to the left of the roundhouse were the railroad's shop complex, where locomotives had been built and repairs made. During its history, the shop produced 78 locomotives. After the facility was closed, all machine work was conducted in the Delano shops, and only a handful of workers remained in Weatherly. After sitting vacant for some time, the huge building was sold in 1913, and the Weatherly Iron and Steel Company purchased the building for $10,000. Today, the complex is empty, and a local civic organization is eying the site for community purposes.

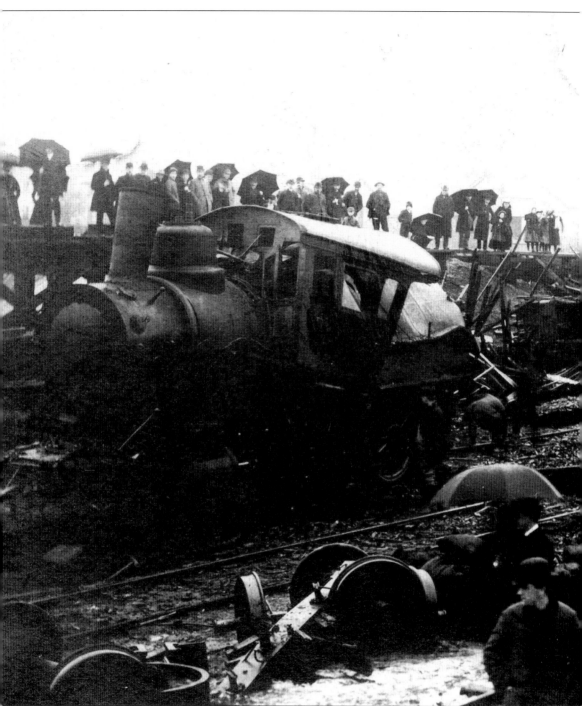

The exact location of this c. 1903 train wreck could not be pinpointed, but the sender of this real photo postcard identified it as being in Weatherly. What appears to be a solid coal train, with cars from the old Delaware, Schuylkill, and Susquehanna Railroad, left the rails possibly after the train's engineer lost control on the infamous Weatherly Hill. Only with heavy enlargement does the outline of a building become visible in the background, but it could not be exactly identified

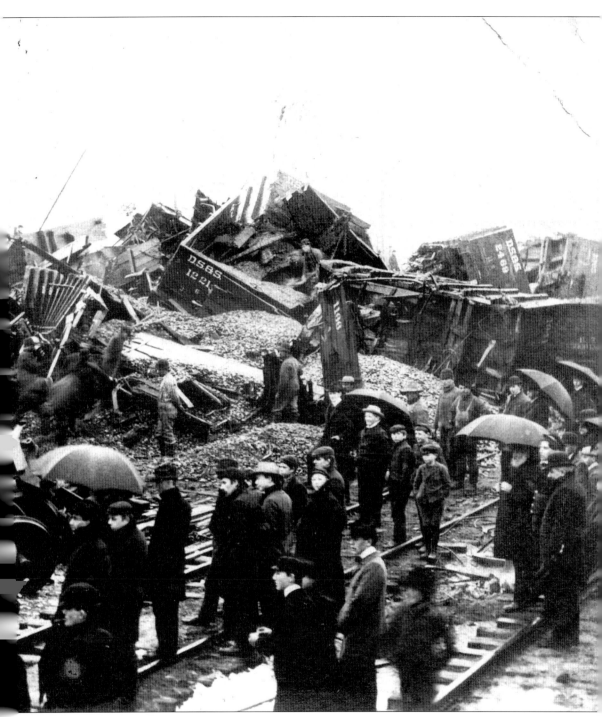

and was likely torn down years ago. The wreck could have also occurred at Penn Haven Junction, five miles from town. Another observation is that the locomotive shown here was of a type commonly used for switching rather than for heavy freight service. One possibility is that the locomotive was working in the Weatherly railroad yard and was struck in the rear by a runaway.

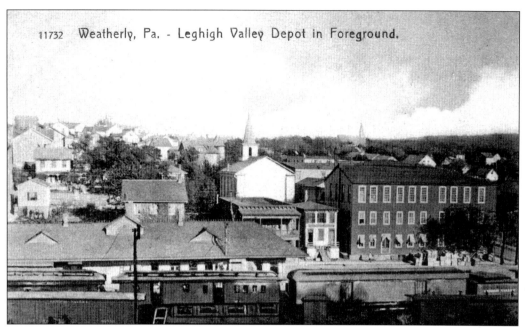

A busy spot on the Lehigh Valley Railroad, Weatherly's passenger and freight station saw much activity during the days when virtually everything that had to travel a distance was shipped by rail. This early scene shows a mix of passenger, freight, and combination cars. Today, a single track passes through the community.

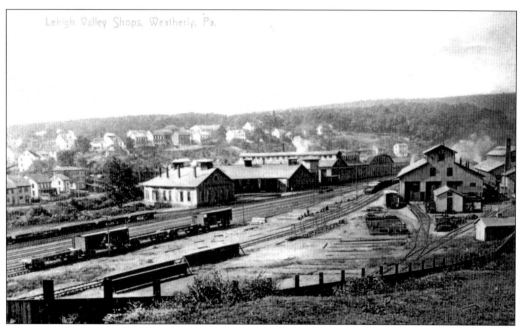

The Lehigh Valley Railroad's Weatherly shop complex was a major employer in the borough. Locomotives and cars were built here until the facility was virtually closed in 1884. However, Weatherly continued to be an important division point on the railroad, and in 1895, over 100 trains were dispatched from there each day.

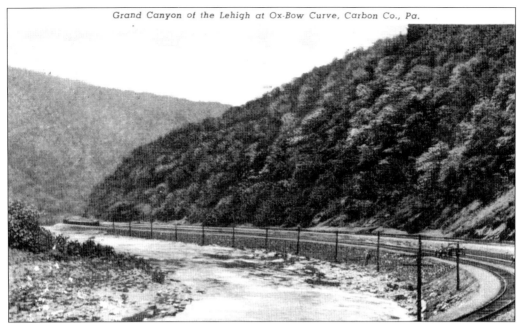

Grand Canyon of the Lehigh at Ox-Bow Curve, Carbon Co., Pa.

Deep in the heart of the Lehigh Gorge, Ox-Bow Curve saw action from two railroads, the Lehigh Valley Railroad and Central Railroad of New Jersey. All freight and passenger trains bound for and coming from Hazleton passed through here. Today, the area is well known to hikers and mountain bicyclists who ride the trail between White Haven and Jim Thorpe.

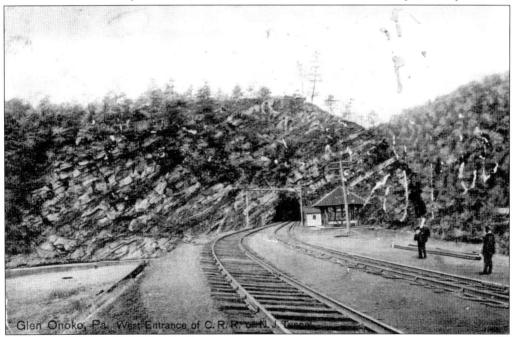

Glen Onoko, Pa. West Entrance of C. R. R. of N. J. Tunnel

Served by two railroads and offering a list of activities, Glen Onoko was a popular destination for both locals and people from as far away as New York City and Philadelphia. The small train station is gone, but the tunnel remains, although rails no longer go through the bore that now ends high above the Lehigh River.

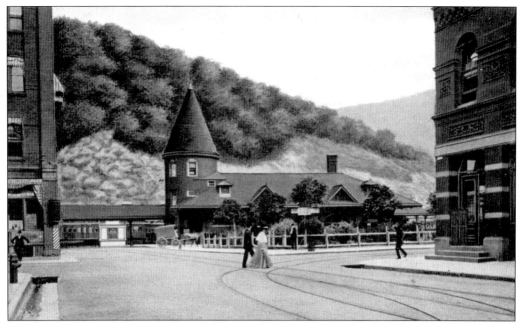

The ornate New Jersey Central Railroad station is still standing in what is today Jim Thorpe, once Mauch Chunk. The railroad also maintained a turntable, coaling station, engine terminal, and yard in Mauch Chunk. Built in 1888, the restored station now houses a bank and small museum dedicated to coal mining and railroads.

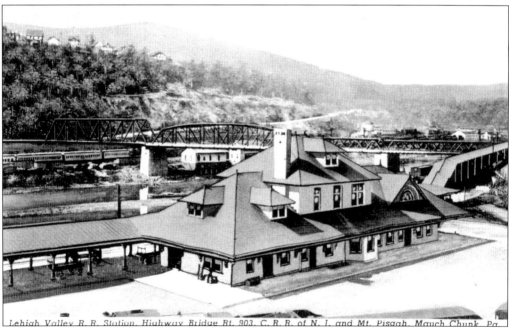

The busy Lehigh Valley Railroad station in Mauch Chunk was actually across the Lehigh River in East Mauch Chunk. Like many other historic buildings, this relic was razed, and the ground is part of a supermarket parking lot. In palmier days, the Black Diamond passenger train stopped here on its way to Buffalo, New York.

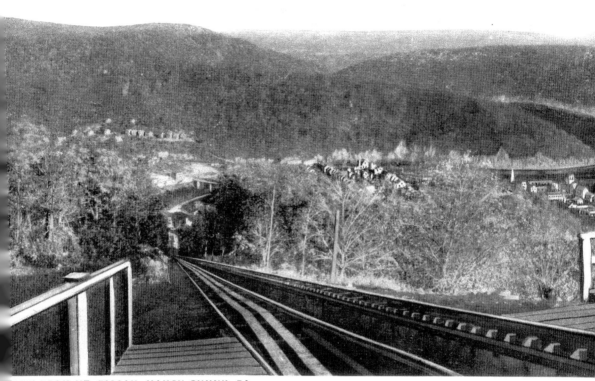

VIEW FROM MT. PISGAH, MAUCH CHUNK, PA. 48593-C

Seen here in a view looking toward the Lehigh River, the Mount Pisgah Plane of the Mauch Chunk, Summit Hill, and Switchback Railroad was the last on the line leading to waiting barges on the Lehigh Canal. It was at the bottom of this plane that the chutes were located, which transferred coal from the Summit Hill area to barges waiting in the canal basin. The chutes are now part of the region's history, and cars no longer travel the switchback railroad. There are many people who believe that the nation's first roller coasters were designed on the same engineering principles that allowed the switchback railroad to operate.

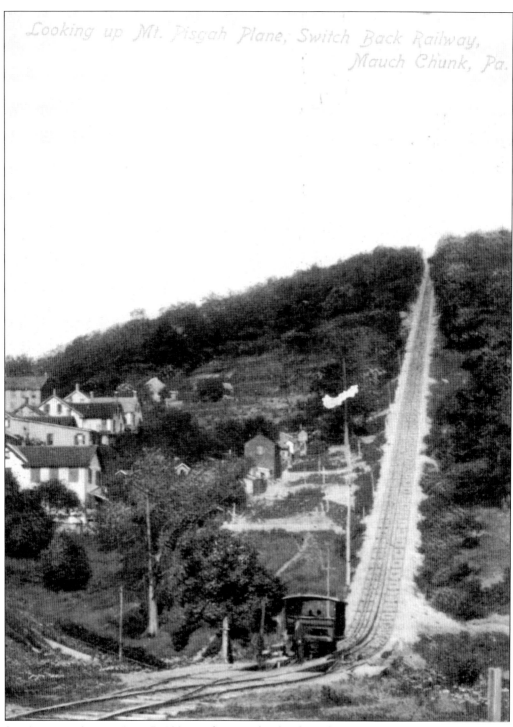

Starting operations on May 5, 1827, as the Mauch Chunk Railroad, the route was later known as the Mauch Chunk, Summit Hill, and Switchback Railroad. When the Lansford Tunnel opened in 1873, the route was no longer needed to transport coal, and it quickly became a popular tourist attraction until being dismantled for scrap.

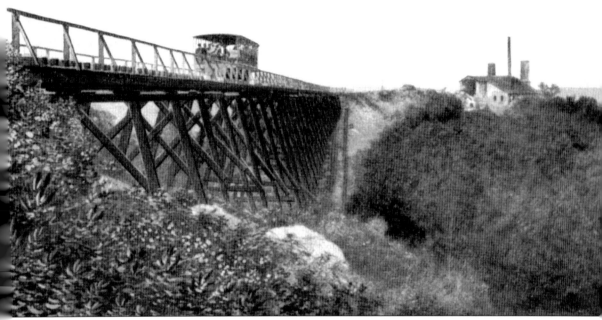

The switchback railroad's Mount Pisgah trestle and powerhouse are seen in the background of this image. The nine-mile route is credited as being the second railroad in the United States. The first was the Granite Railway of Massachusetts, a three-mile route that was constructed to haul granite from Quincy to the Bunker Hill Monument construction site.

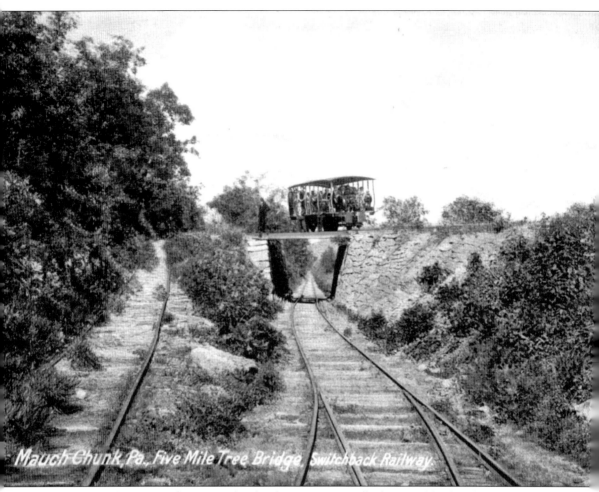

Past the halfway point from Mauch Chunk to Summit Hill, the switchback railroad's Five Mile Tree Bridge was a popular spot for photographers. West of this point, the route passed the Mount Jefferson pavilion and traveled the Mount Jefferson plane before coming into the terminal at Summit Hill. The railroad had one up and one down track.

Nine
Parks and Recreation

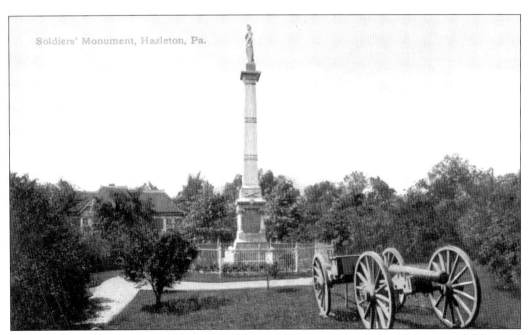

The Civil War monument in Hazleton's Memorial Park, at North Broad Street and Diamond Avenue, was dedicated on September 25, 1885, and none other than Eckley B. Coxe unveiled the monument. Estimates said that 20,000 people attended the event. Reportedly, the Civil War cannons placed in front of the memorial were donated as scrap during World War I. Today, the park is still used for veterans' celebrations.

The Hazleton area is a contrast of tall mountains and deep valleys, and at several places, scenic lookout points were popular destinations. Near Freeland, Pulpit Rock overlooks the Butler Valley and was a popular place for picnickers. Other overlooks were found south of McAdoo and at Glen Onoko, near Jim Thorpe.

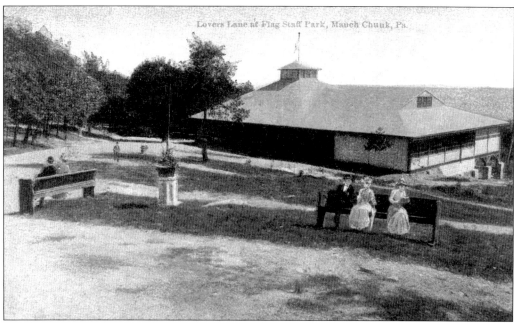

Mauch Chunk's Flagstaff Park was an easy train ride from most places in the Greater Hazleton area. Located high atop a mountain overlooking the town and the Lehigh River, the facility offered food and dancing and is still in operation today. Concerts are still performed there.

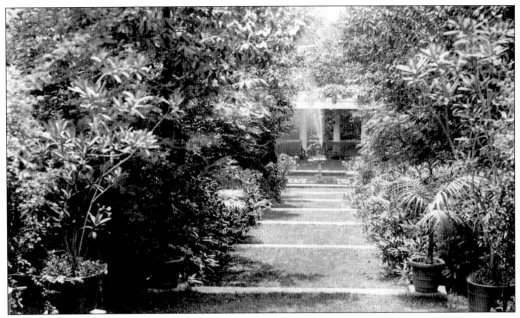

The Italian Gardens at Windy Hill were, at least in 1906, a section of Drifton, which is south of Freeland. Drifton was home to Eckley Brinton Coxe and his wife, Sophia, who was known as the "angel of the anthracite." Sophia Coxe, who died at age 67, is well remembered as being a benevolent woman who freely gave money to help those who were disadvantaged.

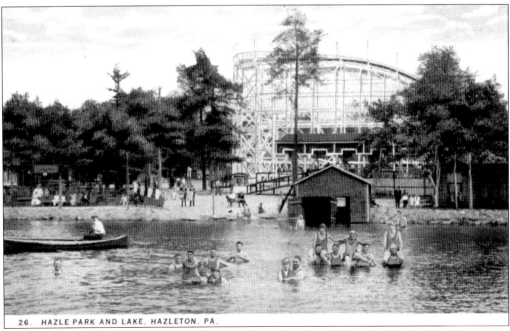

26. HAZLE PARK AND LAKE, HAZLETON, PA.

Hazle Park, in West Hazleton, was built on land provided in 1861 by the Markle Coal Company. Originally a public recreation and picnic area, the park started to change in 1892, when the Hazle Park Amusement Center was established there. Through the years, rides and other attractions were added.

115

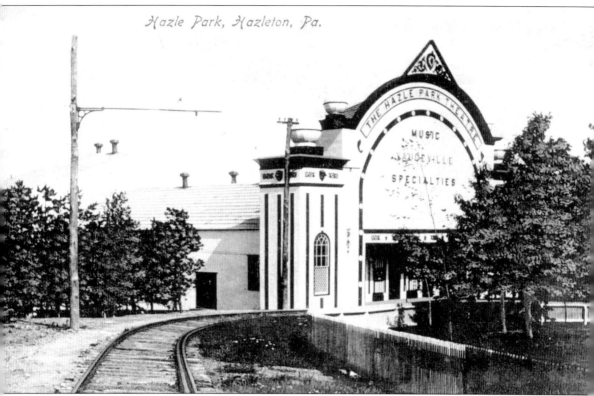

The Hazle Park Theater and the park as a whole were served by the Lehigh Traction Company, which transported thousands of people to the facility each year. In earlier days, it offered tennis courts, a bicycle track, bowling alley, and a large dance pavilion that could hold hundreds of dancers. In its heyday, Hazle Park was one of many in the nation that catered mostly to local people, although due to the Lehigh Traction Company, those living anywhere near its route could make the trip easily. As the years progressed and travel by automobile became common, larger theme parks attracted more and more people from local amusement facilities, often resulting in the closing of smaller places.

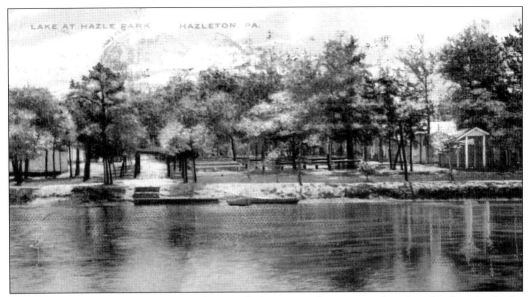

The large Hazle Park Lake was a popular spot for boaters, and many people enjoyed swimming in the clean, spring-fed water. The park was closed in 1956, and Angela Park, north of the city, opened in 1957. To the dismay of many area residents, Angela Park closed in 1989, never to reopen.

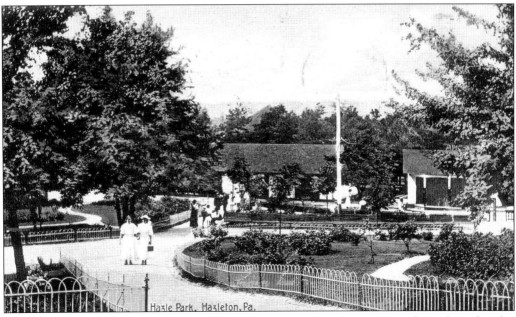

Tidy garden areas were complemented by well-maintained pathways through Hazle Park. This earlier image was undoubtedly made before a collection of rides and amusements were brought to the facility.

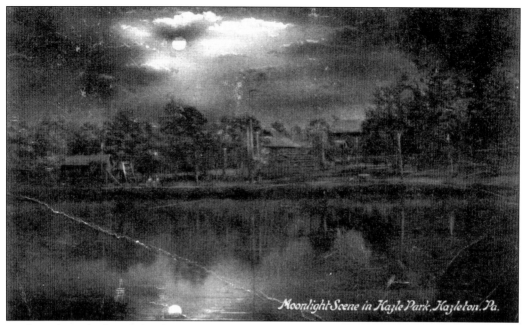

Hazle Park, in the borough of West Hazleton, was a romantic place, especially when the grounds were bathed by the light of a full moon.

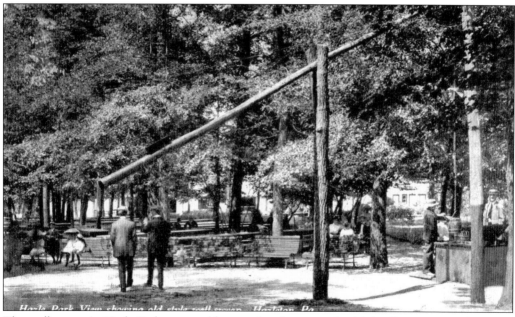

The well sweep in Hazle Park was used by people who wanted a drink of pure mountain water, but they had to get it the hard way. Many places used these devices in the days gone by. Hazle Park is now a distant memory for those who knew and loved the idyllic spot.

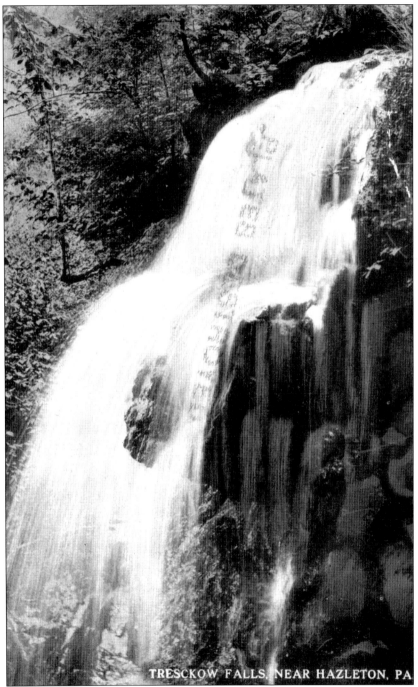

South of Hazleton and Jeanesville, Tresckow is a small Carbon County community that was once considered to be developed as a health resort. Known to most locals, Tresckow Falls is on the south side of the Spring Mountain. Although not always running heavily, water from here eventually reaches Quakake Creek in the valley below. Hiking to the falls was a popular diversion for those living in Tresckow and McAdoo, and a trip there on a spring or summer day was rewarded by cool, clean air and when the leaves changed in the fall, brilliantly colored trees.

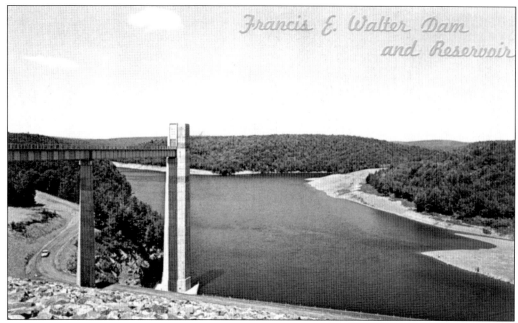

Built as a flood-control project that protects the Lehigh River Valley, the Francis E. Walter Dam is popular today with fishermen and nature lovers. Located northeast of White Haven, the dam protects the cities of Allentown and Bethlehem, as well as the Carbon County boroughs of Jim Thorpe, Lehighton, and Weissport.

At the end of Weatherly's Third Street, Blakslee's Grove was a popular and sequestered place where many residents went to enjoy tranquility on the 23.5-acre wooded tract. Charles M. Schwab and his wife, Eurana, purchased the grove from Rollin A. Blakslee for $7,000. The Schwabs were not residents of the town, but Eurana spent time in the community while growing up.

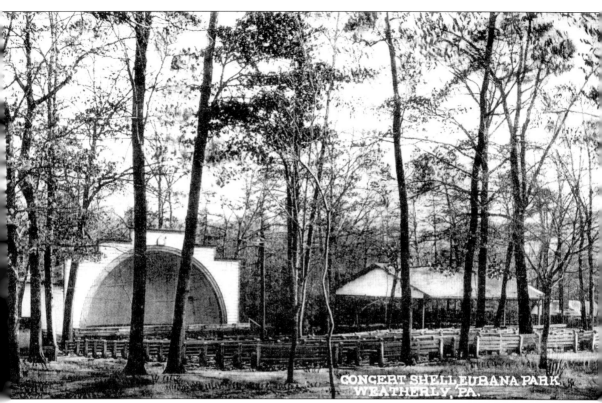

Built in February 1934, the Eurana Park Band Shell has seen considerable use through the years, especially during the spring, summer, and fall months. The tradition continues today, and instrumental concerts held there, often on Sunday evenings, are well attended by both residents and those who travel to the park for an evening of musical entertainment. Many people in the region consider Eurana Park to be one of the finest around, and it is not uncommon to find people from out of town coming to take advantage of its offerings. Annual events such as Christmas in the Park and a community cookout, which are both free to the public, are always well attended.

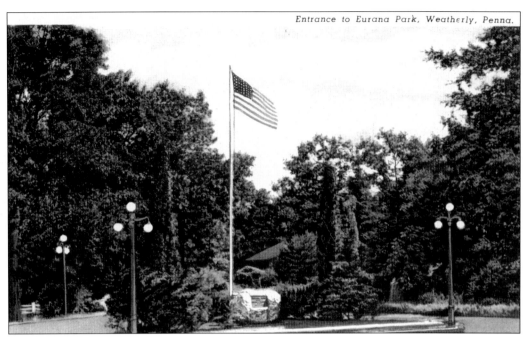

Weatherly celebrated its 50th anniversary on August 22, 1913, and learned that Charles M. and Eurana Schwab had given a second gift to the town, this one being Blakeslee's Grove. The deed to the property arrived on January 26, 1914, and on March 3, 1914, the park was officially named Eurana Park, in honor of Schwab's wife.

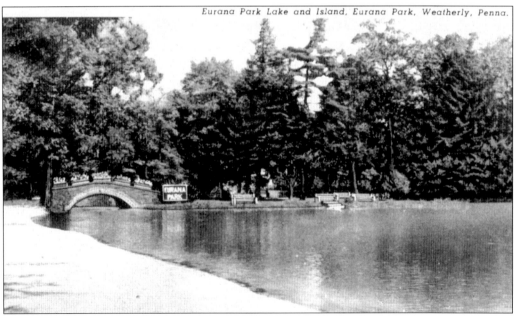

The stone footbridge leading to the island at Eurana Park was constructed in 1932 and remains standing today. The work was performed by a group of men interested in improving the park. This bridge replaced a former span that was constructed of wood.

Open seasonally, the concession stand at Weatherly's Eurana Park is a popular spot during the warm weather, especially on days when swimmers crowd the nearby pool and beach. In recent years, the stand has been staying open later hours, and it has expanded its produce line, which now includes soft ice cream.

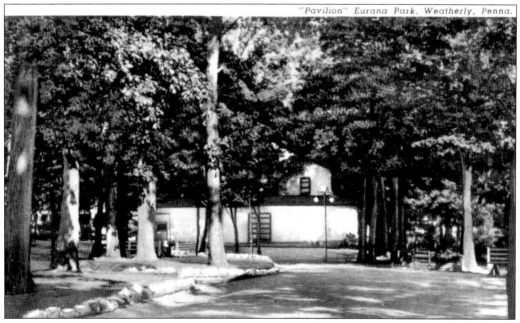

Work on the park's pavilion started in 1917, and the $2,900 building was opened to the public on May 30, 1918. Local high school basketball games were played here until 1937, and a bathhouse was added to the facility in May 1924. The pavilion continues to see use today and is home to the "all night party" of the Weatherly High School's graduating class.

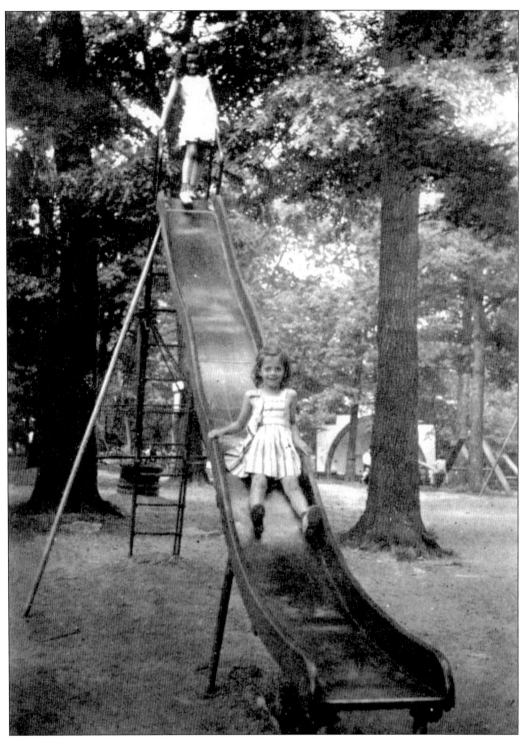

In this photograph, likely taken in the 1940s or 1950s, two girls enjoy the sliding board at Eurana Park. On November 7, 1916, voters approved a $5,000 bond issue that provided improvements to the park, which still remains a popular place for residents of the Carbon County borough.

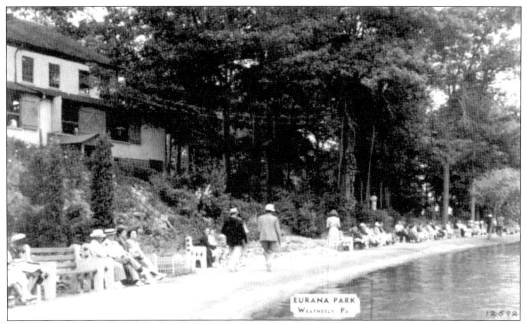

The pool, or lake, at Eurana Park still attracts swimmers during the summer. Eurana Park was one of two found in the borough, the other being Tweedle Park, which was established in 1924. Named in honor of Dr. J. B. Tweedle, the park contained a refreshment stand and dance floor, and it remains a popular place in Weatherly's west side today.

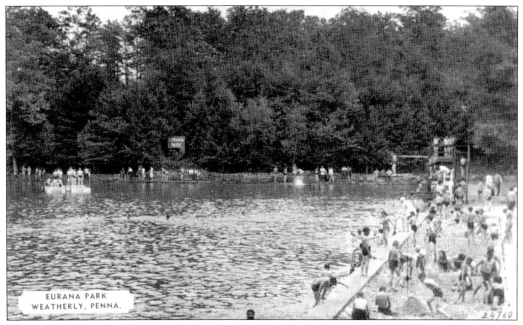

The spring-fed pool at Eurana Park is one of the coolest places on hot summer days. Making the facility attractive to borough residents is the fact that season passes can be purchased at affordable rates.

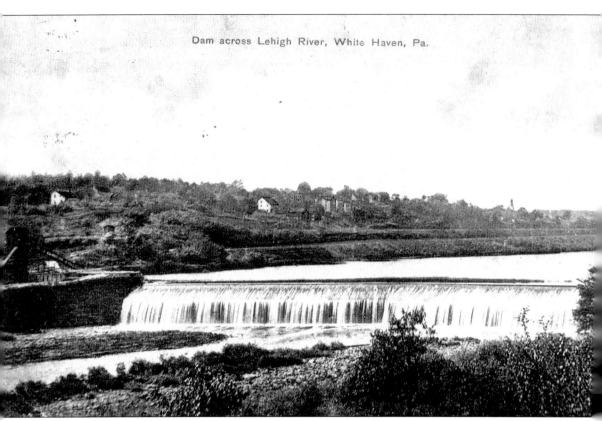

Originally built for the Lehigh Canal, the White Haven Dam created an impoundment that became a favorite place for people to fish, swim, and boat. It continued to be a popular place for years. The Lehigh River runs through Mauch Chunk, Lehighton, Weissport, Walnutport, and eventually Allentown and Bethlehem. In time, concerns arose that if the dam were to burst, the towns and cities downriver would be inundated by floodwaters. It was then decided that the dam would have to be removed due to safety concerns. Ironically, when crews showed up to do the job, it was found that the dam was so strong that conventional methods could not be used. The dam finally was breached when dynamite was used.

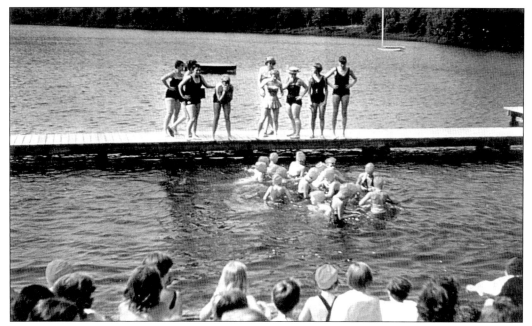

Camp Mosey Wood, near White Haven, was advertised as being "more fun than a barrel of monkeys" on this early-1960s view. This popular Girl Scout resident camp continues to offer adventure and traditional programs for girls.

Hickory Run State Park, east of Hazleton, remains a popular place for camping, picnicking, hiking, and enjoying the outdoors. It is the largest state park in the area, and many people take the short drive from the city to enjoy its offerings.

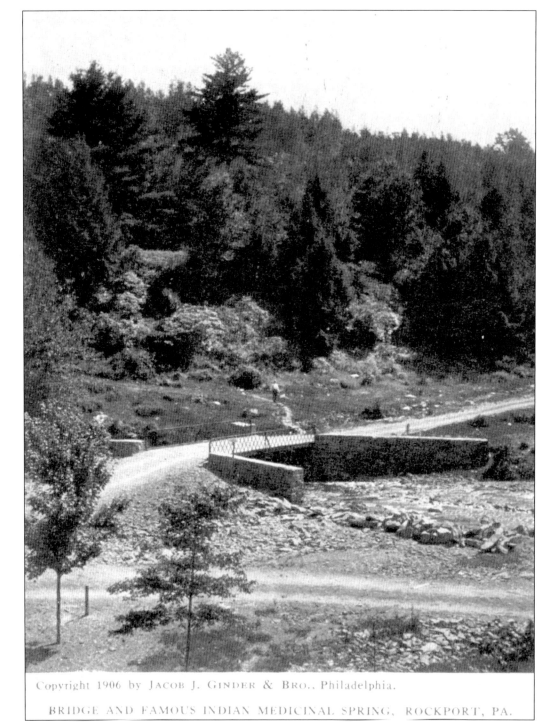

Copyright 1906 by JACOB J. GINDER & BRO., Philadelphia.

BRIDGE AND FAMOUS INDIAN MEDICINAL SPRING, ROCKPORT, PA.

What was called the Indian Medicinal Spring was in the village of Rockport. Before Europeans came to the region, the area surrounding Rockport and north the White Haven boasted large Native American villages, which relied on the Lehigh River and clear streams for water. Through the years, many Native American artifacts were found in farm fields in the general area.